IMAGES
of America

TEXAS GUNSLINGERS

IMAGES
of America

TEXAS GUNSLINGERS

Bill O'Neal

Bill O'Neal
State Historian of Texas

ARCADIA
PUBLISHING

Published by Arcadia Publishing
Charleston, South Carolina

Printed in the United States of America

Library of Congress Control Number: 2014943074

For all general information, please contact Arcadia Publishing:
Telephone 843-853-2070
Fax 843-853-0044
E-mail sales@arcadiapublishing.com
For customer service and orders:
Toll-Free 1-888-313-2665

Visit us on the Internet at www.arcadiapublishing.com

For my sons-in-law: Rudy Martinez,
Drew Gormley, and Dusty Henderson

CONTENTS

ACKNOWLEDGMENTS

This book was proposed to me by Jared Nelson of Arcadia Publishing, and I was delighted at the opportunity to apply the Arcadia treatment to a subject that I have researched and written about for more than 40 years. My editors for this project were Blake Wright and Jeff Ruetsche, who were unfailingly helpful and gracious. The Arcadia production team applied their customary expertise to faded images from the 19th century. *Texas Gunslingers* is my fifth title for Arcadia, and I continue to be impressed by the high quality of professionalism and creativity with which the staff embraces each new book.

Sherri Baker, interlibrary loan specialist at Panola College in Carthage, located obscure books and images for me with her usual zeal for detective work. My first book, *Encyclopedia of Western Gunfighters*, remains in print after 35 years and has been published in several foreign editions. I have written biographies about gunfighters and accounts of feuds and range wars. In putting together these books, I have accumulated a large collection of images, as well as boxes and file cabinets full of gunfighter research. Therefore, when Arcadia Publishing invited me to write about Texas gunfighters, I already had most of what I needed at my home office, and my various acknowledgements of debts have been listed and detailed in earlier books.

But Chuck Parsons, a noted researcher and writer in the field of Texas Rangers and outlaws, granted permission for me to use certain images for this project. My daughter, Dr. Berri Gormley, took needed photographs on short notice at the Texas Ranger Hall of Fame and Museum. On an impromptu trip to Timpson to find and photograph a gravestone, my wife, Karon, and I were given invaluable help by staff members at city hall. And Karon, as always, cheerfully provided a sounding board throughout this project, then prepared the manuscript for the publishers. I could not complete a book without her.

INTRODUCTION

The gunfighter is a compelling figure of the Western frontier. Nothing is more dramatic than life-and-death conflict, and the image of men in big hats and boots brandishing six-shooters and Winchesters has been portrayed in countless novels, movies, and television shows. Nowhere is the gunfighter image more deeply emblazoned than in Texas. Indeed, Texas may be considered the Gunfighter Capital of the West. After the cowboy—a Texas creation—the most colorful and romanticized frontier figure is the gunfighter.

Texas made an enormous contribution to gunfighter lore. The revolving pistol, key weapon of gunfighters, evolved in Texas. Early Texas Rangers, desperate for a repeating weapon that could be used from horseback against mounted Comanche warriors, adapted Samuel Colt's little five-shooter revolvers. Soon, Texas Rangers secured improvements for Colt's pistols, which became larger, more powerful six-guns. Armed with at least two of these six-shooters, mounted Rangers could fire 12 rounds without reloading. In Texas, the US Army learned from Ranger tactics how to combat horseback warriors. In the 1850s, a US Cavalry regiment was organized and stationed in Texas, and each trooper carried a cap-and-ball six-shooter. Soon, these tactics and weapons would be utilized by cavalry units against horseback warriors all over the West.

During the 1850s, these same six-shooters began to be used by Texans against each other. Ben Thompson of Austin became the first gunfighter of note, and many more Texas men began to blaze away at each other with deadly intent and increasing skill. Most Western states and territories saw widespread gunplay for only a brief number of years before law and order prevailed: Kansas, for example, during the cattle-town era; New Mexico during the murderous Lincoln County War; and Oklahoma during its lawless heyday as an outlaw refuge. But in Texas, gunslingers first unlimbered six-shooters against each other during the 1850s and continued to blaze away until past the turn of the century.

A survey of 256 Western gunfighters and 589 shootouts in which they participated (*Encyclopedia of Western Gunfighters*, University of Oklahoma Press, 1979) reveals that Texans dominated the tally sheet of frontier pistoleers. More of these gunfights—nearly 160—occurred in Texas than in any other state or territory. No other Western state or territory was the arena of even half as many shootings. In rating gunfighters according to the number of killings each, as well as the total shootouts participated in, 10 of the deadliest 15 spent most of their careers in Texas. The top 15, with those from Texas italicized, were *Jim Miller, John Wesley Hardin*, Harvey Logan, Wild Bill Hickok, *John Selman, Dallas Stoudenmire, King Fisher*, Billy the Kid, *Ben Thompson*, Henry Brown, John Slaughter, *Cullen Baker, Clay Allison, Jim Courtright*, and *John Hughes*. More gunfighters were born in Texas than in any other state or territory, and more died in Texas.

There were more blood feuds in Texas than in any other state. The Regulator-Moderator War of the 1840s introduced feuding to Texas, and for the next three-quarters of a century, there were vicious outbreaks of violence between families or factions. These feuds featured ambushes, street fights, lynchings, night riders, hired killers, and unforgiving vendettas. Dr. C.L. Sonnichsen, the first student of Texas feuds (*I'll Die Before I'll Run* and *Ten Texas Feuds*) made the observation: " 'Vengeance is mine!' saith the Lord. But in and out of Texas he has always had plenty of help."

Killin' Jim Miller was the West's premier assassin, more lethal than even the legendary Tom Horn. For a time, Miller specialized in killing Mexican sheepherders during the range troubles in Texas between cattlemen and sheep ranchers. Mannen Clements, an in-law of Miller, expressed the same professional outlook: "For three hundred dollars I'd cut anybody in two with a sawed-off shotgun."

Shortly before being hanged for murder in 1878, 27-year-old Bill Longley reflected: "My first step was disobedience; next whiskey drinking; next carrying pistols; next gambling, and then murder, and I suppose next will be the gallows." Dallas Stoudenmire, who repeatedly displayed ferocious courage during Civil War combat and in eight gunfights, confidently proclaimed: "I don't believe the bullet was ever molded that will kill me." But he was proved wrong during an 1882 saloon brawl in El Paso.

It was the deadly risk of gunfighting that attracted novelists and filmmakers. The life-and-death adventures of Western gunfighters captivated audiences, especially when they could see exciting fast-draw contests on the silver screen. In recent years, there has been excellent research into the lives of gunfighters, and today, there are fine books available about Texas gunmen, Texas Rangers, and Texas feuds. Throughout the Lone Star State, there are museums, gun collections, gunfighter sites, and tombstones that exhibit the captivating reality of gunslinging on the Texas frontier.

One

THE CRADLE OF
OLD WEST GUNFIGHTING

Early Texas was settled by pioneers who came mostly from states of the Old South. These Southerners brought to Texas their music, cooking, home crafts, and the institution of slavery. Southern men also brought a proclivity for violence, from eye-gouging, knife-wielding brawls to blood feuds and formal duels. The rough-and-tumble Texas society embraced knife-fighting and pistol duels and blood feuds. The popularity of Sam Houston among Texans was enhanced by an 1827 duel in which he shot and nearly killed his opponent and by an 1832 brawl in Washington, DC, in which he thrashed a congressman who pulled a pistol on him.

Beginning in the 1760s and 1770s, the breakdown of British authority led to bands of "Regulators" who tried to reassert order in Southern colonies through extralegal actions. When Regulators went too far, "Moderators" tried to check their activities. These Regulator-Moderator conflicts continued in the South for decades, resulting in the first and deadliest Texas blood feud.

By the 1840s, a few of Sam Colt's new revolving pistols reached Texas. Capt. Jack Hays of the Texas Rangers, desperately battling mounted warriors armed with repeating weapons—bows and arrows—realized that Colt's small, awkward handguns could give his men repeating weapons to use from horseback. In Texas, these handguns evolved into powerful six-shooters—the iconic weapon of Old West gunfighters.

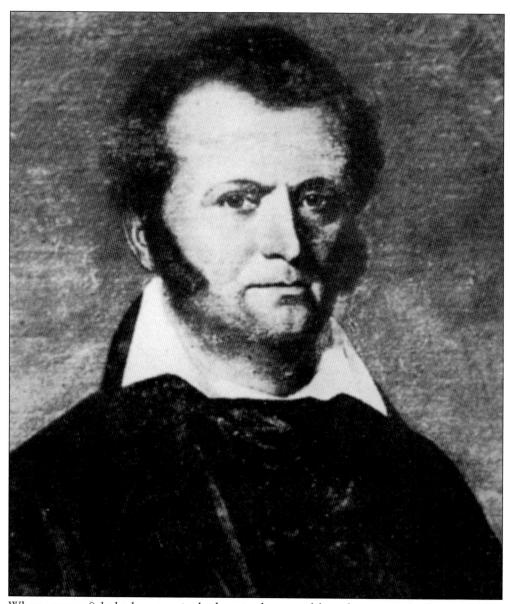

When a tavern fight broke out, a single-shot pistol was good for only one round, after which men went to their knives. The most famous knife-fighter on the frontier was Jim Bowie, who earned widespread notoriety in 1827 during a duel that exploded into a general melee. Despite being shot, stabbed, and beaten, Bowie disemboweled Sheriff Norris Wright and slashed another assailant. The last several years of Bowie's life were spent in Texas, where he died at the Alamo. A gambler who aggressively engaged in a variety of altercations, Bowie, had he lived in Texas a few decades later, would instead have been a gunfighter of renown. (Author's collection.)

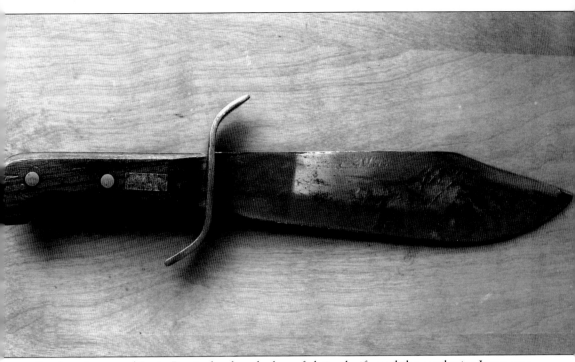

Brothers James and Rezin Bowie developed a large fighting knife, and the combative James was never without his weapon, even when fashionably dressed. The big, heavy blade often had a clip point on top, which held a cutting edge for backstrokes. When David Crockett first saw Bowie's famous weapon, he is said to have remarked that you could tickle a man's ribs a long time before drawing a laugh. In various models, the "bowie knife" became immediately popular in Texas. Other dangerous Texas knife-fighters include Henry Strickland, "The Bully of the Tenaha," who was slain during the Regulator-Moderator War. (Photograph by the author.)

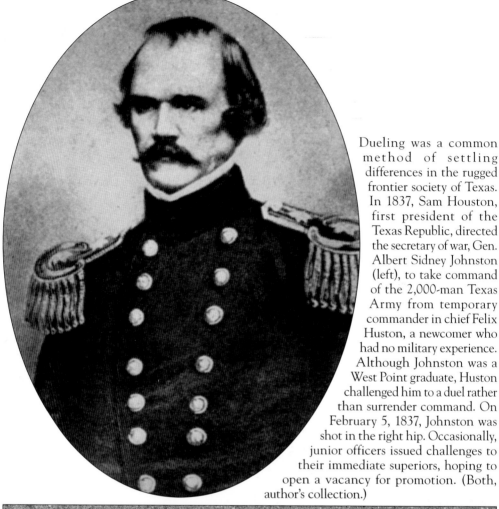

Dueling was a common method of settling differences in the rugged frontier society of Texas. In 1837, Sam Houston, first president of the Texas Republic, directed the secretary of war, Gen. Albert Sidney Johnston (left), to take command of the 2,000-man Texas Army from temporary commander in chief Felix Huston, a newcomer who had no military experience. Although Johnston was a West Point graduate, Huston challenged him to a duel rather than surrender command. On February 5, 1837, Johnston was shot in the right hip. Occasionally, junior officers issued challenges to their immediate superiors, hoping to open a vacancy for promotion. (Both, author's collection.)

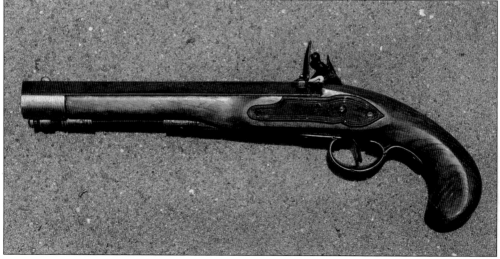

The first of many blood feuds in Texas was the Regulator-Moderator War, a vicious conflict that claimed nearly 40 lives during the 1840s. The killing began late in 1840 in the forested wilderness of newly organized Harrison County, where the Regulator leader was rugged William Pinckney "Hell-Roarin' " Rose. His soaring monument proclaimed, "He was Tower of Strength in War, in State, at Home." (Photograph by the author.)

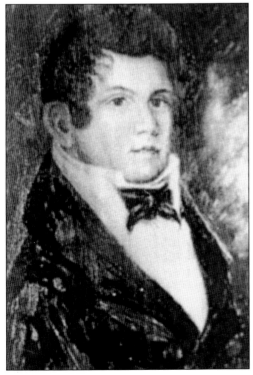

In Harrison County, casualties included Sheriff John B. Campbell, Judge John Hansford, and Peter Whetstone, founder of Marshall, the county seat. Even more prominent was Robert M. Potter (pictured), attacked at his wilderness home by a posse led by William Rose. Potter had signed the Texas Declaration of Independence, served as secretary of the navy during the Texas Revolution, and, at the time of his death, was a senator of the Texas Republic. (Courtesy Jefferson Historical Museum.)

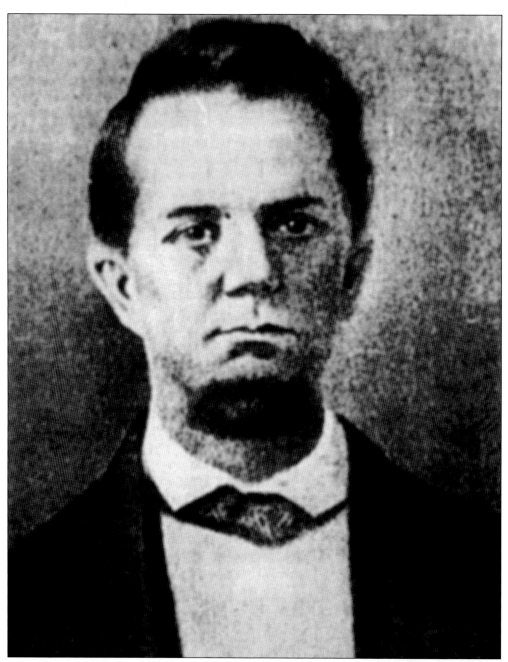

When fighting shifted into Shelby County, Regulator leader Charles Jackson and a companion were ambushed and slain. The new Regulator leader was "Colonel" Watt Moorman (pictured), a hard-drinking bully who wore a cutaway military jacket and carried a brace of pistols, a bowie knife, a bois d'arc cudgel, and a hunting horn to summon his men from the forests. (Courtesy Shelby County Historical Museum.)

After nearly four years of violence, in August 1844, Pres. Sam Houston issued a call for militia volunteers to gather in San Augustine. When Houston rode into town, he was met by 600 men, including officers who had campaigned with him in 1836. The old general quickly organized his men and sent the force marching into Shelby County. Regulators and Moderators promptly dispersed, and their leaders were taken into custody. (Author's collection.)

In the bitter aftermath of the feud, Watt Moorman was shotgunned and buried in a private family cemetery (pictured). In 1847, a young bride was given away by her Moderator stepfather into a Regulator family. The hateful stepfather poisoned the wedding cake, sending almost everyone into convulsions and killing several members at the tragic event. (Photograph by the author.)

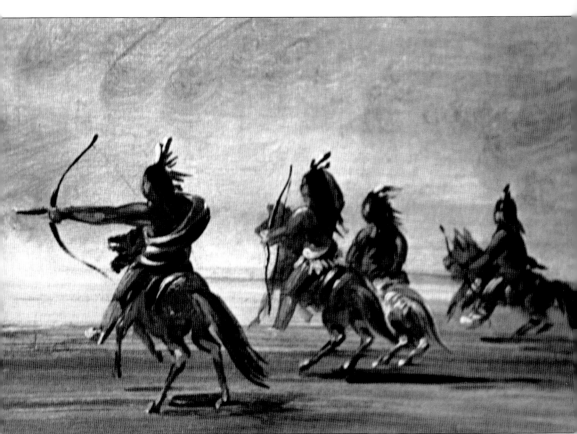

Anglo pioneers first encountered horseback warriors in Texas. Comanche and Kiowa warriors were at their most dangerous as mounted archers, guiding their war ponies with their knees while firing arrows from three-foot bows. A quiver could hold 20 or more arrows, which gave the mounted, mobile warriors a repeating weapon against their Spanish, Mexican, or Texan adversaries. The bowman could fire 20 arrows at the gallop, while his enemy desperately tried to reload his single-shot rifle or horse pistol. The best riders had the smoothest firing platforms. Comanche warriors were regarded as the finest horsemen in the West, and they became the deadliest bowmen. (From *Comanche Giving Arrows to the Medicine Rock* by George Catlin, courtesy Smithsonian American Art Museum.)

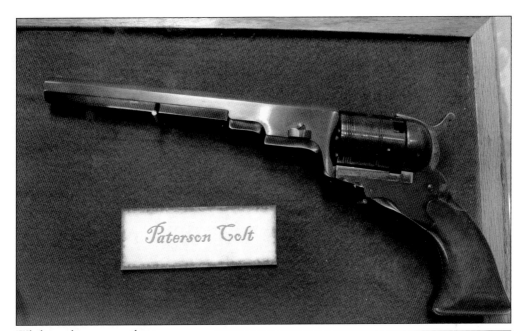

Paterson Colt

While working as a sailor in his teens, Sam Colt developed the idea of a revolving pistol by watching the operation of a ship's tiller drum. In 1836, Colt patented a .34-caliber, five-shot revolver known as a "Texas." The light, poorly balanced pistol had a troublesome trigger and was cumbersome to reload, but it was a repeating weapon that could be used from horseback. (Courtesy Buckhorn Saloon and Museum.)

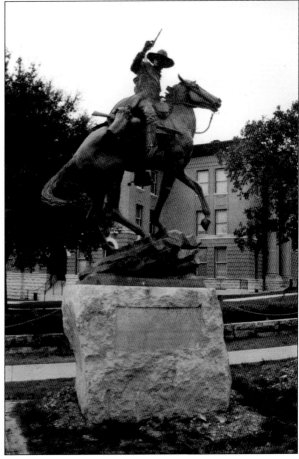

Capt. Jack Hays recognized the potential of using Colt revolvers against Comanche warriors. Hays armed his Texas Rangers with a pair of five-shooters each and worked out tactics for employing them in combat. After using these weapons effectively against horseback warriors, Texas Rangers suggested various improvements. A statue of Hays brandishing a five-shooter is on the courthouse square in San Marcos. (Photograph by the author.)

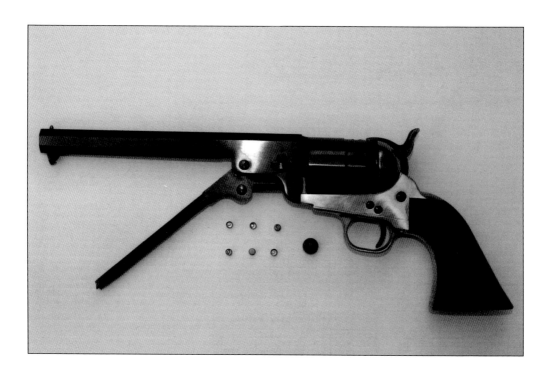

Utilized by the Texas Rangers in horseback combat against Comanche warriors, Sam Colt's early five-shooters evolved by the 1850s into larger six-shooters with plow grip handles and hinged loaders, which rammed powder and shot into each of the six chambers in the revolving cylinder. Nipples behind each chamber were capped with fulminate of mercury percussion caps. Shown above is a Model 1851 Navy Colt of .36 caliber. Below is a .44-caliber 1858 Remington, with a backstrap above a removable cylinder. An extra cylinder, already loaded with powder, shot, and caps, rapidly increased the speed of reloading. Of course, these improved weapons could be used by Texans against each other. (Both photographs by the author.)

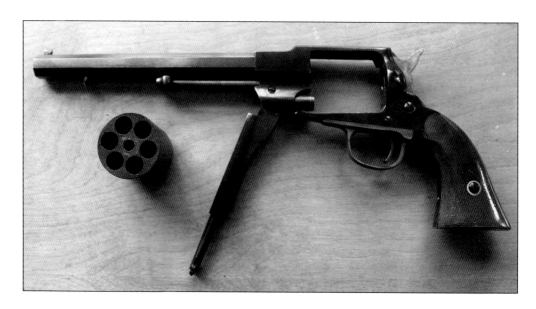

Two

THE DEADLIEST TRIO

The deadliest Texas gunfighters were Ben Thompson, John Wesley Hardin, and James B. "Killin' Jim" Miller. Thompson was the first Texas gunfighter of note. Born in England in 1842, he migrated with his family to Austin, Texas, in 1851. Following a quarrel with another teenager in 1858, Ben ran home, then chased his adversary with a single-barrel shotgun, peppering the fleeing youth with birdshot. The next year, an angry clash while geese hunting brought another adolescent face-off, this time with shotguns at 40 paces. Ben and his opponent were both wounded. Soon, Ben Thompson would be trading .45 slugs in his confrontations.

John Wesley Hardin was born in 1853 in Bonham. The son of a Methodist preacher, young Wes learned to handle firearms as a hunter and by shooting at effigies of Abraham Lincoln during the Civil War. In 1868, when he was 15, Wes pumped three pistol slugs into a former slave. During the next several years, the kill-crazy young outlaw was involved in one gunfight after another.

In 1867, when little Jim Miller was one year old, he moved with his family from Arkansas to Texas. Within a few years, the boy's parents died, and he was sent to live with his grandparents in Evant. When Jim was eight, his grandparents were murdered in their home. The boy was arrested, then released to live with a married sister on a farm near Gatesville. But the hot-tempered youngster clashed with his brother-in-law, and Jim shot him while he slept, setting the pattern for his life.

All three members of this deadly trio died violently. Killer Miller was lynched; Wes Hardin was shot dead in El Paso; and Ben Thompson was assassinated in San Antonio.

Ben Thompson was 19 when the Civil War began. He joined the Confederate army and served the duration of the war in Texas, New Mexico, and Louisiana. During an off-duty monte game at Laredo, trouble erupted, and Thompson shot two Mexicans to death. He injured a leg when his horse fell on him while he was smuggling whiskey, but while on medical furlough, he married Catherine Moore, daughter of a well-to-do Austin family. After the war, Thompson was jailed in Austin following gunplay with occupation troops. In 1868, he wounded his brother-in-law for striking his wife. During a saloon fight in 1876 in Austin, saloonkeeper Mark Wilson fired a shotgun at Thompson, who killed Wilson with three pistol shots, then wounded bartender Charles Matthews in the mouth. (Courtesy Western History Collection, University of Oklahoma Library.)

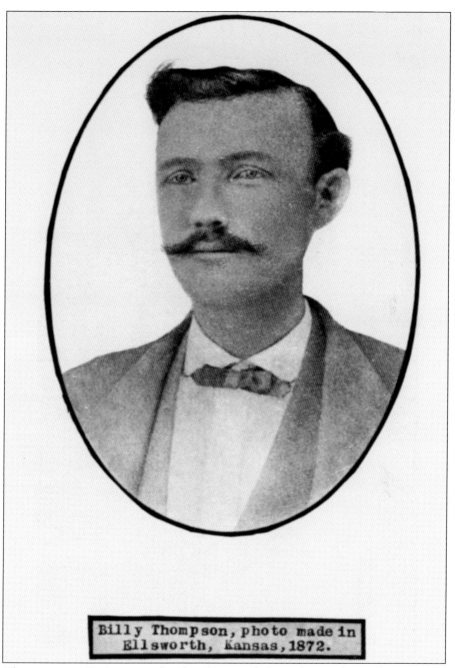

Billy Thompson, photo made in
Ellsworth, Kansas, 1872.

Billy Thompson was Ben's younger brother. He served alongside Ben during the Civil War, and he shared Ben's propensity for drinking, gambling, and gunplay. In 1868, Billy killed a US Army sergeant at Austin, and Ben helped him escape the state. Ben and Billy were in and out of Kansas cattle towns as gamblers during the early 1870s. In Ellsworth in 1873, a drunken Billy accidentally shotgunned Sheriff C.B. Whitney. "My God, Billy," exclaimed Ben, "you've shot our best friend!" Again, Ben helped Billy escape. In 1882, Billy hid in El Paso for several months to escape a murder charge in Corpus Christi. It was rumored that he was killed in Laredo about 1892. (Courtesy Western History Collection, University of Oklahoma Library.)

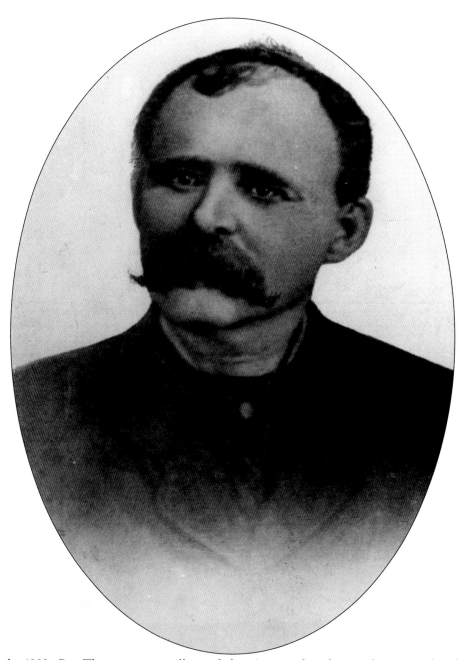

By the 1880s, Ben Thompson was well-regarded in Austin, where he quietly supported orphans and dressed well around town. In 1881, he was elected Austin's city marshal. The next year, he ventured into the Vaudeville Theatre and Gambling Saloon, the most notorious night spot in San Antonio. The Vaudeville was owned by Jack Harris, who for two years had nursed a grudge against Thompson over a gambling dispute. When told that Thompson had entered his building, Harris seized a shotgun and concealed himself behind venetian blinds. Spotted by Thompson, Harris raised the shotgun. But Thompson palmed a revolver and triggered a fatal round. Thompson surrendered himself, resigned as city marshal, and, following acquittal, was met in Austin with a spontaneous parade by well-wishers. (Courtesy Eakin Press.)

On March 11, 1884, Ben Thompson met his friend King Fisher, deputy sheriff from Uvalde, who was in Austin on official business. The two men had several drinks, then Thompson decided to travel by train with Fisher as far as San Antonio. On the train, the men continued to drink and were quite rowdy. In San Antonio, they saw a play in the evening, and at 10:30, they went to the theater where Jack Harris had been killed two years earlier. Thompson and Fisher had a drink, then were attacked by several friends of Harris. Thompson managed to get off one shot before dying with nine wounds. Fisher was struck 13 times. Most of the wounds were caused by shotgun and rifle fire, and there were powder burns on their faces. (Both, author's collection.)

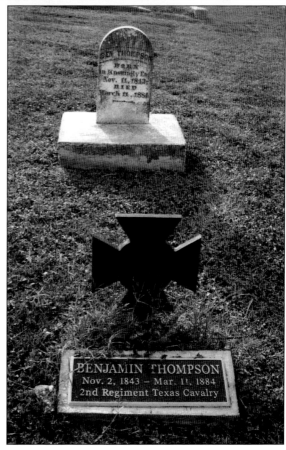

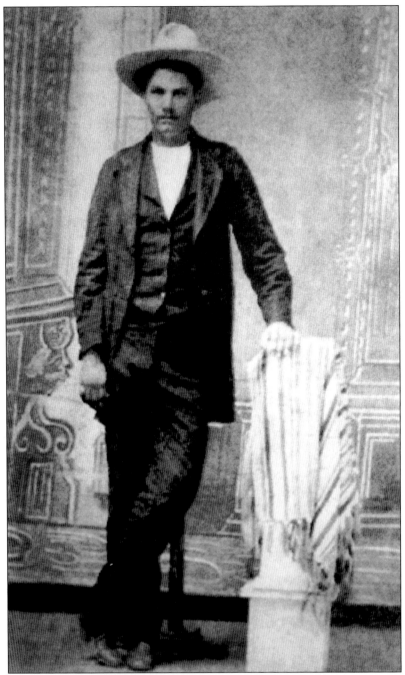

After killing a former slave near Moscow in East Texas, Wes Hardin went on the run. Pursued by a trio of Reconstruction soldiers, he set an ambush near a creek crossing. There, two soldiers were shotgunned, and Wes killed the third man with a .44 revolver. Several former Confederates concealed the corpses while Wes, wounded in the arm, fled the scene. He began to drink and gamble, and there were other shootings. Early in 1871, he was arrested near Marshall, but he shot a guard and escaped. Soon, he left the state with a cattle drive, but, after reaching Kansas, he killed two more men. (Author's collection.)

In Texas in 1872, Hardin wounded members of the state police in two incidents, but he caught buckshot in the side. In Cuero in 1873, Hardin killed a deputy sheriff, and, later in the year, he killed Sheriff Jack Helm (pictured). The next year, Hardin celebrated his 21st birthday in Comanche. During an exchange of shots with Deputy Sheriff Charles Webb, Hardin was wounded in the side, but he drilled the lawman in the head. Hardin fled town ahead of an enraged mob, but his brother Joe and two other companions were captured and lynched. The State of Texas placed a $4,000 dead-or-alive reward on the head of John Wesley Hardin. (From Hardin's autobiography, *Life of John Wesley Hardin, As Told by Himself*, 1896; pen and ink drawing by J. Onderdonk.)

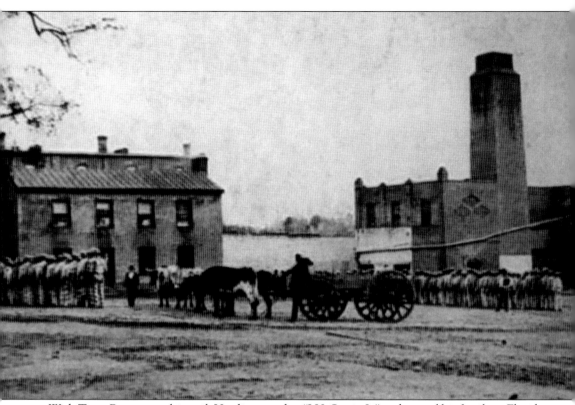

With Texas Rangers on his trail, Hardin passed as "J.H. Swain Jr." and moved his family to Florida and Alabama. His wife, Jane, bore him two daughters and a son. For three years, "Swain" lived quietly, but in 1877, Texas Ranger John B. Armstrong found him on a train in Pensacola. "Texas, by God!" shouted Hardin as the Ranger drew his long-barreled Colt .45. Hardin's revolver caught in a suspender, but, beside him, 19-year-old Jim Mann triggered a round that punched a hole in Armstrong's hat. The Ranger killed Mann with a bullet to the heart, then clubbed Hardin with his pistol barrel. Back in Texas, Hardin was sentenced to the penitentiary in Huntsville (pictured). (Author's collection.)

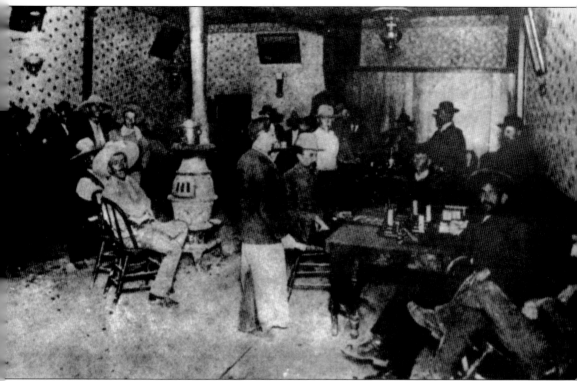

An 1870s scene in a Pecos saloon features what is believed to be Jim Miller in the white hat, seated at a gambling table. During part of his time in Pecos, Killin' Jim wore the badges of city marshal and of deputy sheriff. A feud broke out with Sheriff Bud Frazer, who twice opened fire on Miller in Pecos, in April and December 1894. Each time, Miller was hit in an arm or leg, but the deadliest rounds were deflected by a steel breastplate he often wore beneath his shirt. Frazer fled to New Mexico, but in 1896, Miller trailed him to a saloon in Toyah, west of Pecos. Killin' Jim blasted away most of Frazer's face, and when Bud's sister cursed the murderer, he threatened to shoot her, too. (Author's collection.)

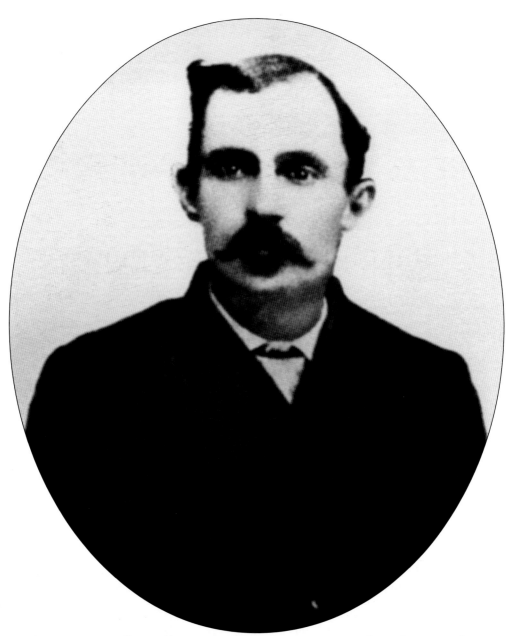

By the 1890s, Jim "Killer" Miller was the West's premier assassin, often riding great distances afterward to establish an alibi. "I have killed eleven men I know about," he told a Fort Worth acquaintance, before adding with disdain, "I have lost my notch stick on sheepherders I've killed out on the border." In 1899, he ambushed and killed Joe Earp, who had testified against him during a trial. The murders continued into the 20th century. It took four rounds to finish Lubbock lawyer James Jarrott. "He was the hardest damn man to kill I ever tackled," admitted Miller. In 1904, Miller killed Frank Fore in a Fort Worth hotel, and two years later, he shotgunned lawman Ben Collins. Little wonder that when Pat Garrett was murdered in 1908, widespread blame was placed on Miller. (Courtesy Western History Collections, University of Oklahoma Library.)

Three

GUNFIGHTER GALLERY

More gunfighters operated in Texas than in any other state or territory. More gunfighters were born in Texas, and, in the Lone Star State, more shootists died—often violently. Gunmen who earned most of their notoriety elsewhere nevertheless engaged in their first gunplay in Texas: Doc Holliday, in Dallas; Bat Masterson, in Mobeetie; and Henry Brown, in a panhandle cow camp. There were Texas expatriates, men who took their deadly kills elsewhere. Tall Texan Phil Coe was drawn to booming Abilene, Kansas, where he was killed in a street fight with Wild Bill Hickok. Joe Horner, a fast-shooting Texas outlaw, fled the state and changed his name to Frank Canton. He was a hired gunman during Wyoming's Johnson County War. He later achieved high position and respectability in Oklahoma.

Of course, there were Texans who spent their entire careers in Texas. Pink Higgins was raised on the Texas frontier, and he used his preferred weapon, a Winchester, against adversaries for nearly four decades. Higgins, incidentally, was the father of nine children, more than any other Western gunman. King Fisher was the father of four daughters, but he used his guns on both sides of the law, and he was assassinated at the age of 30.

Twice, there were lynchings by gunfire, with gun barrels shoved between the bars of jail cells in Belton (1874) and Meridian (1878). Father and son Emmanuel Clements and Emmanuel Jr. were shot dead in Texas saloons about two decades apart. And, just as revolving pistols had evolved in Texas before the Civil War, after the war, Texan shootists utilized the latest revolvers, rifles, and gun rigs.

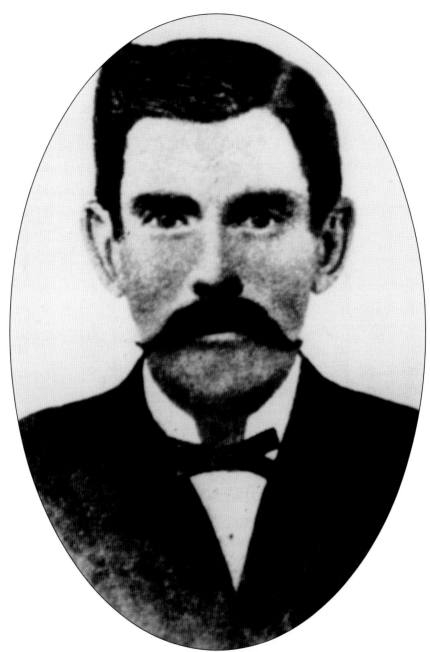

By the time he earned a DDS from the Pennsylvania College of Dental Surgery, young John H. Holliday had contracted tuberculosis. Hoping to prolong his life, Doc Holliday moved to the drier climate of the West. The 23-year-old dentist opened an office in Dallas, but he took an immediate interest in drinking and gambling. On the first day of 1875, Holliday exchanged shots with a saloonkeeper named Austin. No one was hit, but Holliday did better during the next several years, usually in saloon fights. He gunned down two men in shootouts in Las Vegas, New Mexico, and he shot four more antagonists in Tombstone and Tucson, Arizona, and in Leadville, Colorado. Most famously, he killed Tom McLaury at Tombstone's OK Corral. But the West's deadliest dentist first engaged in gunplay in Dallas, Texas. (Courtesy Kansas State Historical Society, Topeka.)

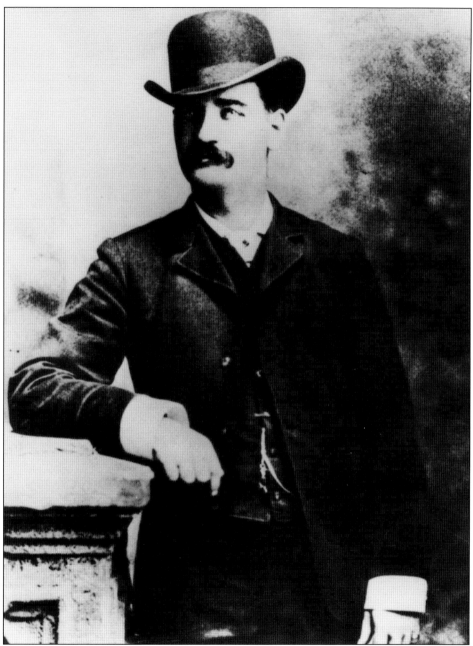

At the age of 19, William B. "Bat" Masterson was a member of the small party of buffalo hunters that fought off several hundred Comanche warriors at the Battle of Adobe Walls in the Texas Panhandle on July 27, 1874. Following this desperate battle, Masterson scouted for the Army for a time and hunted buffalo. On January 24, 1876, Masterson, 22, was involved in a wild saloon shootout in Sweetwater (later Mobeetie), near Adobe Walls. Masterson and saloon girl Mollie Brennan apparently were in each other's company at the Lady Gay when Cpl. Melvin King, from nearby Fort Elliott, roared into the saloon and fired his service revolver. Mollie and Masterson both were shot before Bat drilled King in the heart. King and Mollie died, but Masterson recovered from his hip wound. (Courtesy Kansas State Historical Society, Topeka.)

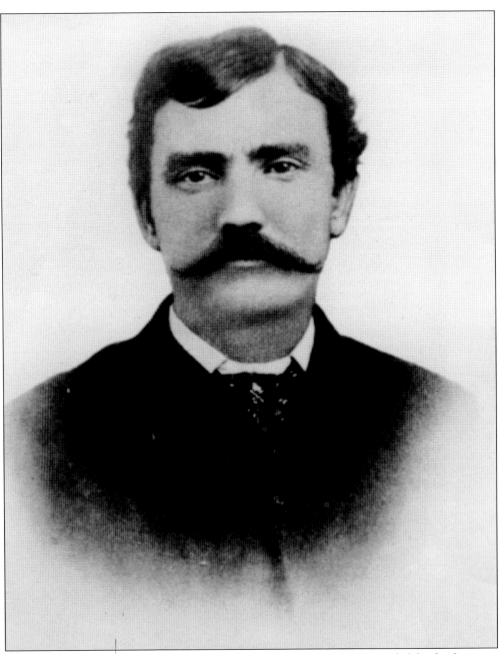

John King Fisher was a native Texan who had a troubled boyhood, being jailed for the first time at 16. As a young man, he cowboyed in south Texas, where he broke horses, chased Mexican bandits, and learned to shoot. A gaudy dresser, Fisher sported fringed shirts, crimson sashes, and bells on his spurs. He became a colorful and dominant figure in the nearby border town of Eagle Pass, and he was feared as a rustler, nailing up a celebrated crossroads sign that read, "This is King Fisher's Road—Take the other one." Fisher admitted to killing seven men, including four vaqueros in a blazing shootout on his ranch in 1875. The next year, he married, fathering four daughters. In 1884, Fisher, in the wrong place at the wrong time, was assassinated alongside Ben Thompson in San Antonio. (Courtesy Western History Collections, University of Oklahoma Library.)

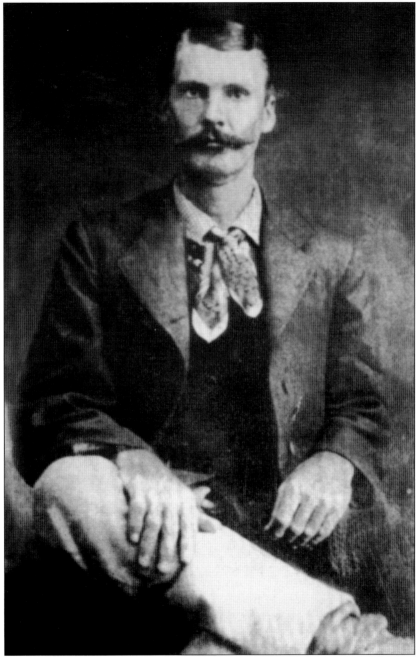

John Calhoun Pinkney "Pink" Higgins was raised on his family's Lampasas County ranch during the 1850s and 1860s. The county suffered Comanche raids, and the only defense was neighborhood pursuit posses. Pink's father left his son, tall for his age and a good rifle shot, to defend the home while he rode with pursuers. But, by the time he was 14, Pink Higgins was riding with posses while his father stayed at home. Twice, Higgins was wounded in these combats. When he was 18, he helped chase down a rustler, then adjusted the noose around the man's neck. While still a teenager, he became a drover on trail drives, and he was a trail boss within a few years, ready to meet trouble with his Winchester. (Courtesy Standard Studio, Lampasas.)

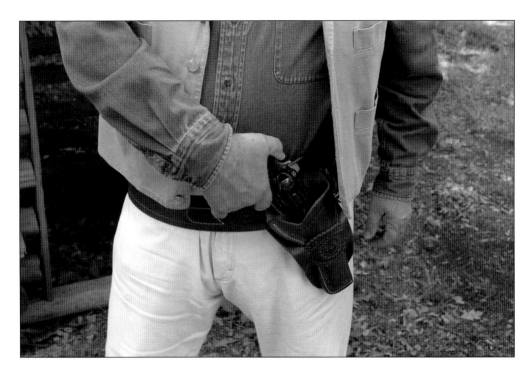

With cartridge revolvers came cartridge belts, and holsters were made to fit over the gun belt. A man could wear his holster for a cross-draw (above), which was especially useful while in the saddle. When he dismounted, the gunman could slide the holster to his hip for faster access (below). (Both photographs by Karon O'Neal.)

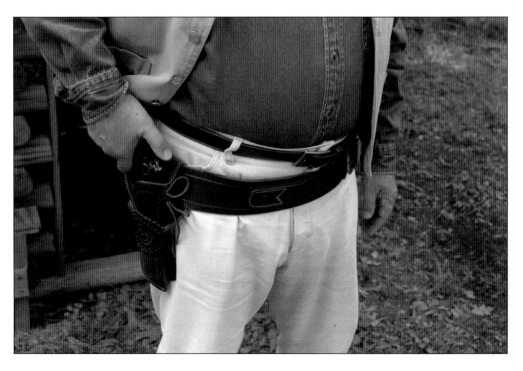

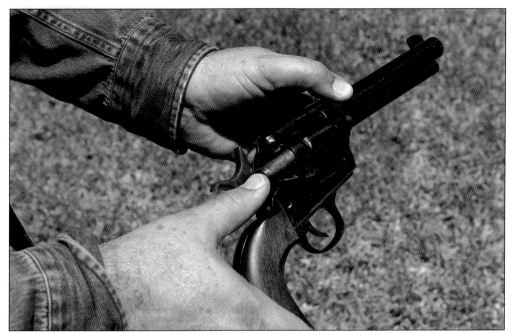

To load a single-action Colt .45, pull the hammer back to half-cock, so that the cylinder will revolve freely. Open the loading gate and insert cartridges into the chamber. Since single-action Colts have no safety, it was considered prudent to carry only "five beans in the wheel," leaving the chamber beneath the hammer empty. (Photograph by Karon O'Neal.)

Some men shoved their pistols into their waistbands or hip pockets, while others preferred a shoulder holster beneath their coat. (Photograph by Karon O'Neal.)

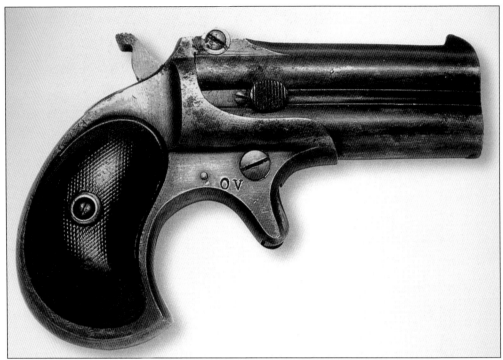

Many gunslingers carried a hideout gun as a backup. Perhaps a "belly gun"—a small, short-barreled revolver—was slipped into a coat or pants or vest pocket. More popular was the derringer, only a few inches long and easy to conceal. More than 150,000 of these .41-caliber Remington "Over and Under" hideout guns were sold. (Author's collection.)

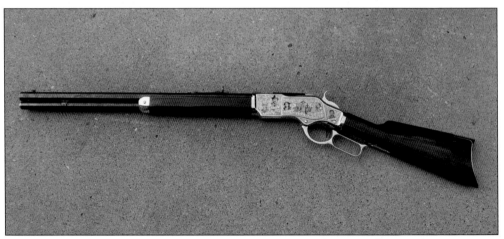

After the Civil War, Oliver Winchester reorganized the Winchester Repeating Arms Company, and the first Winchester, a lever-action repeater, was introduced in 1866. The Model 1873 became an immediate classic, the best-selling rifle in the West. The Winchester '73 (pictured) was so popular that Colt chambered its single-action Peacemaker for the same .44 cartridge so that a man could use interchangeable ammunition in his revolver and his shoulder gun. (Photograph by the author.)

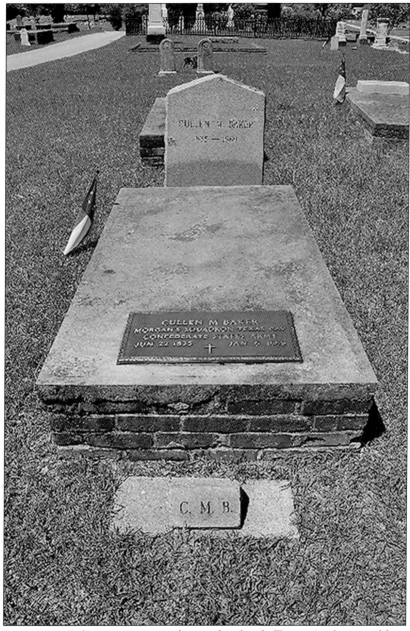

Cullen Montgomery Baker was a vicious desperado of early Texas. At the age of four, in 1839, the boy moved with his family from Tennessee to the Republic of Texas. His father received a land grant in Cass County, where Cullen grew up to be quarrelsome and a problem drinker. In 1854, when he was 19, Baker killed his first man, and, two years later, he claimed his second victim. In 1861, he enlisted in a Confederate troop in Cass County, but he deserted, joined the Union army, then deserted again and joined a gang of bandit raiders. After the war, Baker organized a gang of thieves, and, after a number of depredations, he was chased down and killed in East Texas in 1869. On his corpse were found a shotgun, four revolvers, three derringers, and six pocketknives. Cullen Baker was buried at Jefferson's Oakwood Cemetery. (Photograph by the author.)

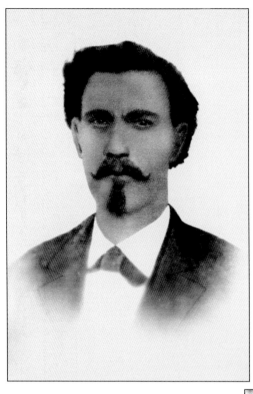

Born in 1851, native Texan William Preston Longley became known as "Bloody Bill" during the gunfighter era. He shotgunned Wilson Anderson for killing a relative. Bloody Bill murdered Rev. William Lay, who was milking a cow. He killed Lou Shroyer in a running fight, and two other victims brought his total to five before he was arrested by two Texas lawmen in 1877. The officers slipped into Louisiana and, at shotgun point, "extradited" Longley back to Texas. Jailed at Giddings, he was tried and convicted of murder. When Longley was hanged, five days short of his 27th birthday, he died with courage, although his knees dragged the ground and he had to be hoisted up and rehanged. (Left, courtesy Western History Collections, University of Oklahoma Library; below, author's collection.)

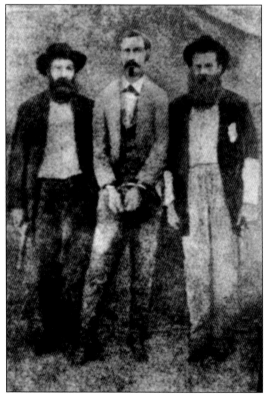

In 1879, actor Maurice Barrymore (right), father of Lionel, Ethel, and John and great-grandfather of Drew, brought his traveling troupe to Marshall for a performance at the Mahone Opera House. That night after the show, Barrymore and fellow thespians Ellen Cummins and Ben Porter traded insults in a restaurant with drunken railroad detective Big Jim Currie. Barrymore, an accomplished boxer, doubled his fists and approached Currie, but Big Jim produced a hammerless Smith & Wesson five-shooter, plugged Barrymore in the shoulder, and mortally wounded Porter. Eastern newspapers severely castigated Texas and Texans, especially after Currie won acquittal. But, as the local saying went, "Steal a hog, get sent to jail; kill a man, get set free." (Both, author's collection.)

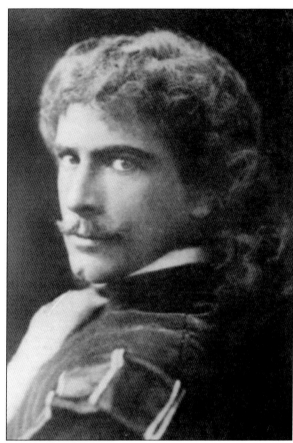

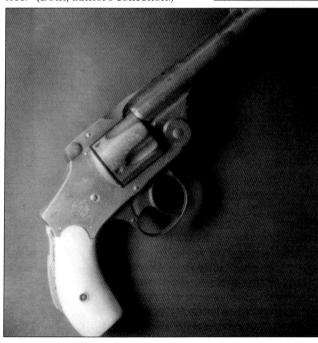

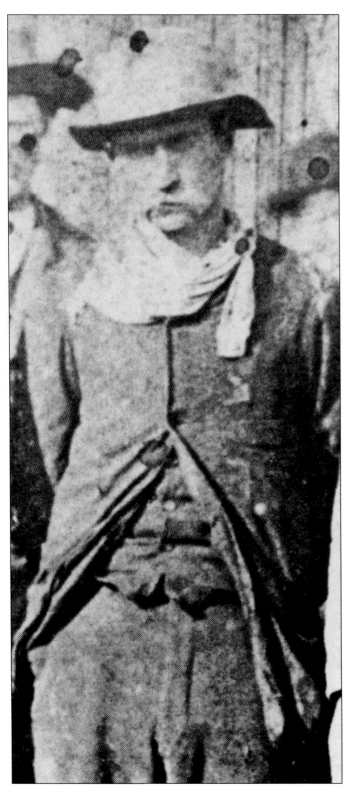

Henry Newton Brown was orphaned as a boy, and at 17, he left his native Missouri to seek adventure in the West. Brown worked as a cowboy, and in 1876, he turned up in a cattle camp in the Texas Panhandle. Brown was outwardly courteous and soft-spoken, but a lethal ferocity lurked below the surface. In the camp, he quarreled with a fellow cowboy, then pumped three slugs into his adversary—the first of several victims. In New Mexico, Brown fought on both sides of the Lincoln County War and later ran with outlaw Billy the Kid. Back in Texas, Brown wore a deputy's badge in Tascosa. As city marshal of Caldwell, Kansas, he tamed the raucous cattle town. But Marshal Brown led a murderous bank robbery at Medicine Lodge, Kansas, and was lynched with his gang. (Courtesy Kansas State Historical Society, Topeka.)

Phil Coe, Texas gambler and saloon owner, had a long connection with Ben Thompson. The two men served together in the 2nd Mounted Texas Rifles in 1862. After the Civil War, Coe opened a saloon in Austin and installed Thompson as a house gambler. In 1871, Coe and Thompson owned the Bull's Head Saloon in Abilene, Kansas. An obscene sign at the Bull's Head attracted the ire of city marshal Wild Bill Hickok. Even though Thompson and Coe soon sold out, Coe continued to have trouble with Wild Bill, flooring him during a fistfight. On October 5, 1871, Coe went on a drunken spree with about 50 fellow Texans. When challenged by Hickok, Coe fired a shot, which missed, and Wild Bill drilled Coe in the stomach. Coe died four days later and was taken back to Texas for burial. (Right, courtesy Chuck Parsons; below, courtesy Kansas State Historical Society, Topeka.)

West Texan Barney Riggs drifted into Arizona Territory long enough to kill his employer and earn a life sentence in Yuma Territorial Prison. But during an attempted prison break, Riggs picked up a revolver and shot a convict, helping to save the warden's life and winning a pardon. Riggs returned to Texas, ranching west of Pecos. In 1896, Riggs was assaulted in a Pecos saloon (above) by John Denson and Bill Earhart. A round from Earhart's revolver grazed Riggs, who coolly drilled his assailant between the eyes. Denson fled the premises, but Riggs put a slug into the back of his head. In Fort Stockton six years later, Barney Riggs was shot dead by a step-grandson. (Both photographs by the author.)

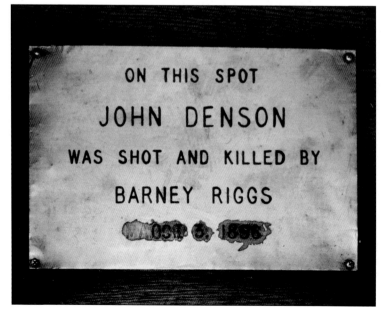

Emmanuel "Mannen" Clements and his brothers, Gyp, Jim, and Joe, were brought up on a cattle ranch south of Smiley. During the Sutton-Taylor Feud, the Clements brothers—related by marriage to the Taylors—were involved in several ambushes and sieges. Their cousin, John Wesley Hardin, fought alongside them, and Mannen once broke him out of jail. In 1887, while drinking in Ballinger's Senate Saloon, Mannen was shot dead by city marshal Joe Townsend. (Courtesy Western History Collections, University of Oklahoma Library.)

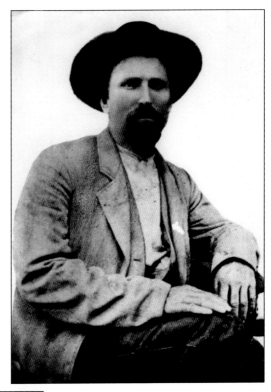

Emmanuel "Mannie" Clements Jr. was as violence-prone as his father. Following an 1894 murder in Alpine, Mannie relocated to El Paso. For the next 14 years, he wore badges as a deputy constable, constable, and deputy sheriff. By marriage, Mannie became a brother-in-law of Killin' Jim Miller. Indicted for armed robbery in 1908, he was assassinated in El Paso's Coney Island Saloon. (Courtesy Western History Collections, University of Oklahoma Library.)

In 1871, when he was 18, A. John Spradley was twice wounded in a fight with two brothers named Hayes. But Spradley shot both brothers to death, fled from Mississippi to Texas, and, within several years, assumed the vacated sheriff's office of Nacogdoches County. During his long tenure, Sheriff Spradley sometimes had to defend himself; in 1893, he killed fast-shooting saloonkeeper Joel Goodwin. In 1884, Spradley was shot through the torso while trying to make an arrest. But a resourceful doctor used a ramrod to push a whiskey-soaked silk handkerchief through the wound to heal it, and Sheriff Spradley lived to be 87. (Author's collection.)

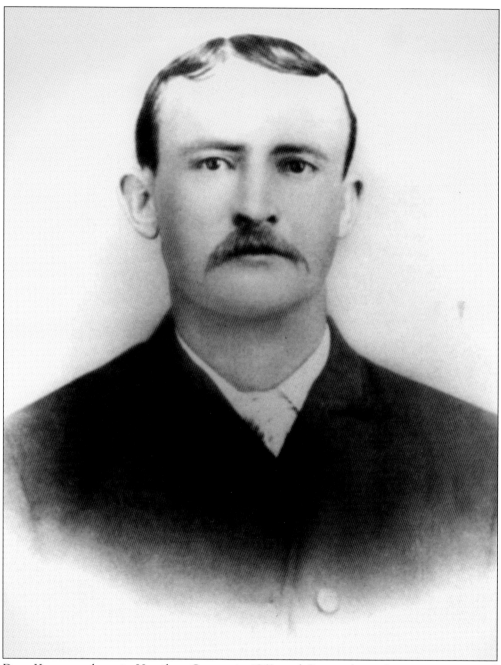

Dave Kemp was born in Hamilton County in 1862, and Comanche raiding parties remained active in the area throughout his boyhood. When Kemp was 15, a fight broke out on Hamilton's courthouse square. Young Kemp killed a man named Smith and turned his gun on the sheriff before being seized from behind. Sentenced to hang, he tore away from his guards and leaped from a second-floor courthouse window. He broke both ankles in the fall but somehow scrambled onto a horse before being subdued. Gov. Richard Hubbard commuted the teenager's sentence, then issued a pardon. Kemp moved to New Mexico, killed Sheriff Les Dow, and returned to Texas, where he lived out his days as a rancher—and peace officer! (Author's collection.)

After the Civil War, teenaged Texan Joe Horner began herding cattle up the Chisholm Trail for famed rancher Burk Burnett. By his early 20s, Horner had established a small ranch north of Jacksboro. But he stole horses from Indian reservations in Oklahoma, then began stealing livestock from fellow ranchers. In 1874, he engaged in a shootout with troopers from nearby Fort Richardson. There was other gunplay, and in 1875, he was jailed in Jacksboro. Within a week, Horner was broken out of a flimsy lockup, probably by his three brothers. In 1876, "the Horner Gang" robbed a bank in Comanche of $5,500, but after a furious shootout with a posse, Joe was cornered. Twice more he escaped custody, fleeing Texas in 1879. (Courtesy Jim Gatchell Museum, Buffalo, Wyoming.)

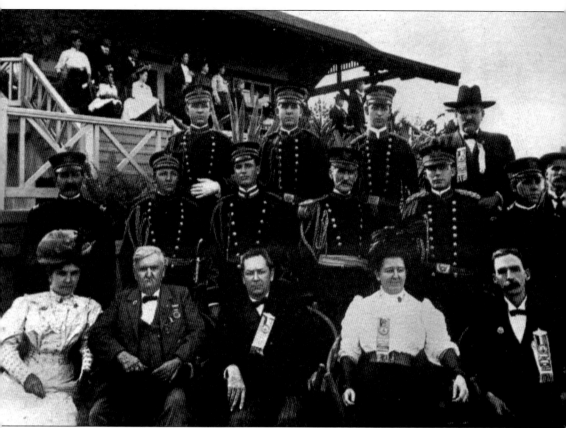

Joe Horner changed his name to Frank Canton and found a fresh start on the Wyoming frontier. He became sheriff of Johnson County, married, and became a father. Soon, Canton was a gunslinging operative of the powerful Wyoming Stock Growers Association (WSGA). In the infamous Johnson County War, the expatriate Texas gunslinger was a cold-blooded assassin. During the 1892 climax of the range war, Canton and his WSGA allies were reinforced by more than 20 gunmen from Texas. After being cleared by legal machinations, the Texans returned to Texas. But Canton/Horner stayed away from Texas, eventually becoming adjutant general of the Oklahoma National Guard. He is seen here, at center with gray mustache. (Courtesy Western History Collections, University of Oklahoma Library.)

Temple Lea Houston was Sam Houston's youngest child and the first baby born in the Texas governor's mansion. Temple was not yet three when his father died, and, at the age of 12, he rode off to become a Texas cowboy. At 13, Temple helped drive a herd of cattle to Dakota Territory. He clerked for two years in the US Senate, enrolled in the first class of Texas A&M College, and graduated from Baylor University at 19. A lawyer, Houston was appointed district attorney for the Texas Panhandle, working out of turbulent Tascosa and Mobeetie. He dressed flamboyantly and carried a white-handled Colt he called "Old Betsy." An expert shot, he frequently won money in shooting contests, and, during two gunfights in the 1890s, he drilled each of his adversaries. (Courtesy Western History Collections, University of Oklahoma Library.)

A native of Tennessee, Clay Allison
served the Confederacy during the
Civil War. Soon after Appomattox,
he and most of the rest of his family
moved to Texas. In 1866, he was one
of 18 drovers who rode with Texas
cattlemen Charles Goodnight and
Oliver Loving, blazing the historic
Goodnight-Loving Trail. Allison later
became a trail boss before establishing
a ranch in New Mexico. He engaged
in gunplay in New Mexico and in
Colorado, killing four adversaries.
In 1887, while ranching about 40
miles from Pecos, he drove a wagon
into town for supplies. On the way
back, rumored to have been drunk,
he fell from the wagon, fractured
his skull on a front wheel, and died.
He was buried in Pecos. (Right,
courtesy Western History Collections,
University of Oklahoma Library;
below, photograph by the author.)

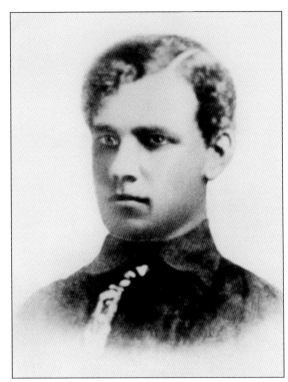

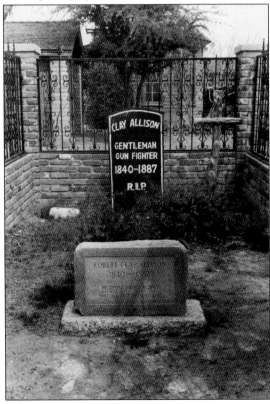

49

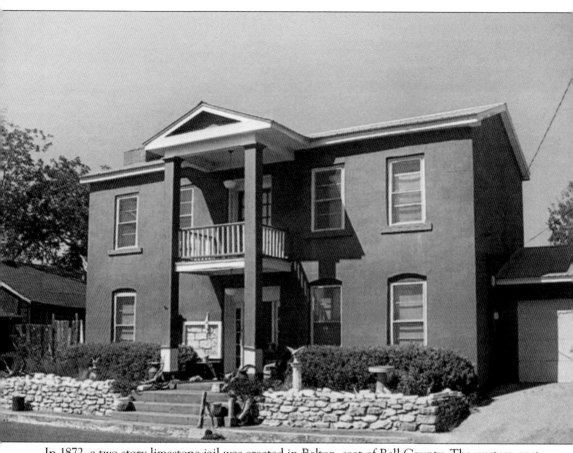

In 1872, a two-story limestone jail was erected in Belton, seat of Bell County. The western part of the county is hilly, broken country, which provided hideouts for rustlers and assorted fugitives. But, in the spring of 1874, the sheriff led a sweep of the outlaw haven. Soon, 10 criminals were tossed inside the big iron-slatted cage in the new jail. The worst of the lot was a man who had murdered his wife with an axe. On the night of May 26, with the sheriff out of town, a large lynch mob stormed the jail. As the prisoners cowered at the rear of the cell, rifle and revolver muzzles were fitted between the slats. Volley fire killed nine men. An ill prisoner had been isolated in another room; he was later sentenced to life in prison. The 1872 jail later was converted to a private residence. (Author's collection.)

Four

TEXAS RANGERS

The Texas Rangers are the most famous law-enforcement body in the world. The Ranger force was created to battle horseback warriors on the Western frontier and Mexican raiders on the border. For more than three decades, Texas Rangers fulfilled this military role, including notable service during the war with Mexico.

Texas was the only Confederate state with a frontier. But, during the Civil War, there was little military presence on the Texas frontier, and for two years after the war, Union troops functioned as a Reconstruction occupation force. Texas proposed to organize 1,000 Texas Rangers for duty on the frontier, but the last thing Reconstruction officials would permit was 1,000 armed Texans.

In 1874, however, with Texans back in charge of the state, the legislature authorized the Frontier Battalion of Texas Rangers. There would be six companies—A, B, C, D, E, and F—with 75 men each. Military organization prevailed: each company would have a captain, lieutenant, sergeants, corporals, and privates. Gov. Richard Coke appointed Maj. John B. Jones, a distinguished Civil War officer, as commander of the Frontier Battalion with the rank of major of Rangers.

For a year, the Frontier Battalion fought numerous engagements against war parties and border raiders. In 1867, the US Army returned to the frontier, and Texas Ranger companies soon were reduced in size. Major Jones now turned the efforts of the Frontier Battalion to law enforcement. Texas Rangers hounded killers and rustlers, intervened in blood feuds, and established a fearsome presence as fast-shooting lawmen.

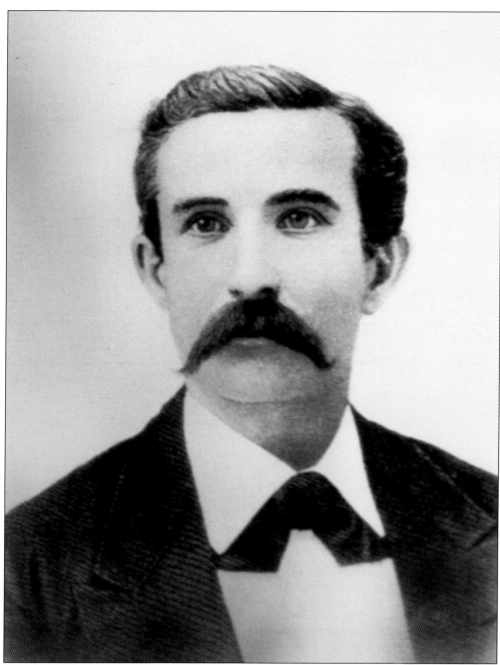

A native of South Carolina, John B. Jones was born in 1834 and moved to Texas with his family when he was four. Well-educated for the time, he distinguished himself as a Confederate officer, rising to the rank of major. In 1874, he was appointed major in command of the Frontier Battalion of Texas Rangers. The Ranger reorganization was efficiently led by Major Jones, who also led his men in frontier combat against Comanche war parties. The Indian wars finally at an end, Jones focused attention on outlawry and feuds. He effected a truce in the Horrell-Higgins Feud and engineered the manhunt for Sam Bass. Appointed adjutant general of Texas in 1879, he simultaneously commanded the Frontier Battalion until his premature death in 1881. (Author's collection.)

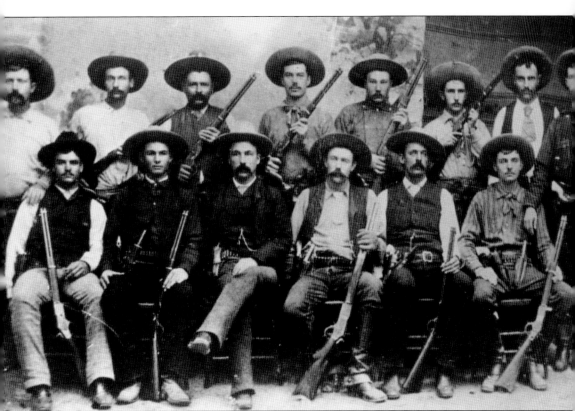

Frank Jones was born in Austin in 1856. Enlisting in the Texas Rangers, Jones (first row, third from left) eventually rose to the command of Company D. He was active along the Mexican border, running to earth rustlers, train and bank robbers, and an assortment of dangerous criminals. On June 30, 1893, Captain Jones led five other officers in pursuit of several cattle thieves. Crossing the Rio Grande, there was a running fight, in which two of the rustlers were wounded. The gang holed up in an adobe building at tiny Tres Jacales. Captain Jones was shot off his horse, but he straightened his broken leg in front of him and fired his Winchester from a sitting position. Suddenly, a slug tore into his chest, and he gasped, "Boys, I am killed." (Courtesy Texas Ranger Hall of Fame and Museum.)

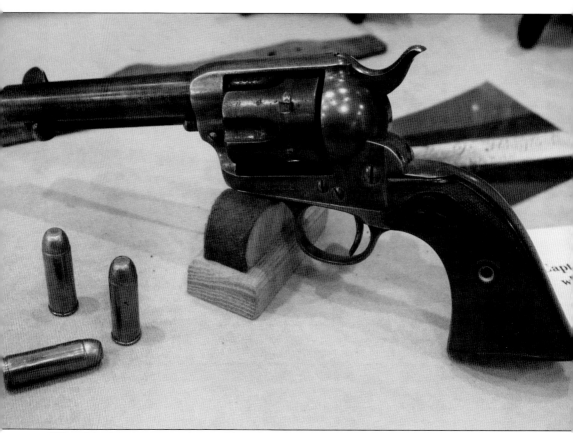

When John Hughes was a 15-year-old cowboy, during a brawl in 1872, he took a rifle bullet through his clothing, was nearly knifed, and was wounded in his right arm. The arm was permanently impaired, and he had to switch gun hands, becoming so skilled that most people thought he was a natural southpaw. After several years as a trail driver, Hughes acquired a small horse ranch near Liberty Hill. In 1886, six rustlers stole nearly 100 horses, including 18 belonging to Hughes. He tracked them for a year, twice shooting his way out of ambushes. Finally, with the help of a deputy sheriff, Hughes killed four of the rustlers and recovered the stolen herd. During his trek, he rode 1,200 miles, used up nine mounts, and spent all but 76¢ of the $43 with which he started. This Colt .45 revolver belonged to Hughes. (Courtesy Buckhorn Saloon and Museum.)

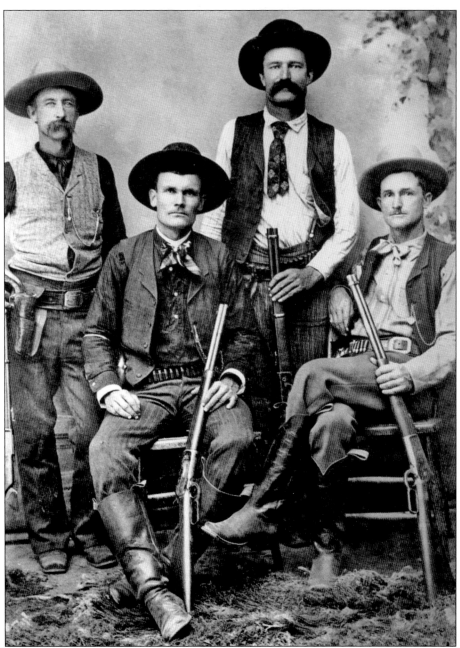

Soon after returning to his ranch, Hughes (seated, right) helped Texas Ranger Ira Aten track down escaped murderer Judd Roberts. When confronted by the two manhunters, Roberts reached for his guns, but he was riddled by six bullets. Shortly afterward, in August 1887, Hughes enlisted as a Ranger, beginning 28 years of service. Promoted to corporal by 1889, he uncovered an ore theft ring at the silver mines of Shafer. Setting a trap with two other officers, Hughes and his men engaged in an hour-long rifle duel, in which three of the thieves were killed. On Christmas night, 1889, Hughes led three other officers in setting an ambush at a Rio Grande crossing for rustlers Will and Alvin Odle. The Odle brothers tried to fight, but they were shot out of their saddles. (Courtesy Western History Collections, University of Oklahoma Library.)

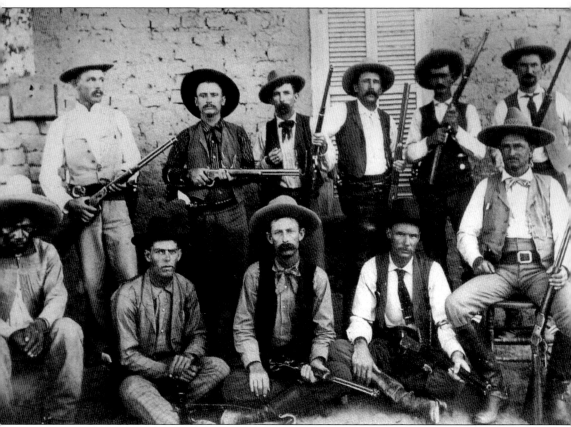

In 1893, now a sergeant, Hughes (seated at far right) and two of his men encountered a trio of fugitives at a village on the border. When one outlaw tried to flee, Hughes and Lon Oden gave chase and killed the men. Also in 1893, Hughes was promoted to captain of Company D, following the death of Capt. Frank Jones in a border shootout. In 1896, Captain Hughes led a posse in pursuit of three horse thieves, who tried to make a stand on a hilltop. The posse advanced on foot, and when rustler Jubel Friar raised up to fire at Hughes, Ranger Thalis Cook drilled him through the chest with a Winchester slug. Friar's brother, Art, was twice wounded but fired his revolver at Hughes and Cook. The two Rangers pumped one bullet apiece into Art Friar, who fell dead. (Author's collection.)

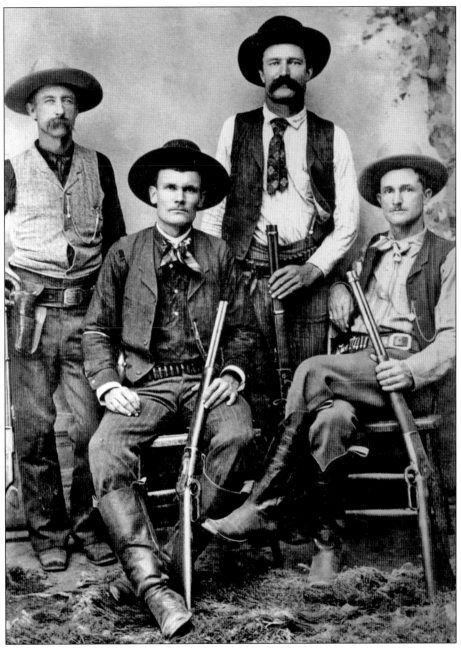

Soon after returning to his ranch, Hughes (seated, right) helped Texas Ranger Ira Aten track down escaped murderer Judd Roberts. When confronted by the two manhunters, Roberts reached for his guns, but he was riddled by six bullets. Shortly afterward, in August 1887, Hughes enlisted as a Ranger, beginning 28 years of service. Promoted to corporal by 1889, he uncovered an ore theft ring at the silver mines of Shafer. Setting a trap with two other officers, Hughes and his men engaged in an hour-long rifle duel, in which three of the thieves were killed. On Christmas night, 1889, Hughes led three other officers in setting an ambush at a Rio Grande crossing for rustlers Will and Alvin Odle. The Odle brothers tried to fight, but they were shot out of their saddles. (Courtesy Western History Collections, University of Oklahoma Library.)

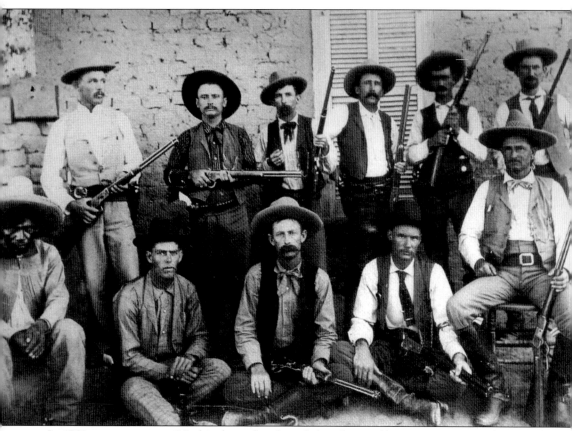

In 1893, now a sergeant, Hughes (seated at far right) and two of his men encountered a trio of fugitives at a village on the border. When one outlaw tried to flee, Hughes and Lon Oden gave chase and killed the men. Also in 1893, Hughes was promoted to captain of Company D, following the death of Capt. Frank Jones in a border shootout. In 1896, Captain Hughes led a posse in pursuit of three horse thieves, who tried to make a stand on a hilltop. The posse advanced on foot, and when rustler Jubel Friar raised up to fire at Hughes, Ranger Thalis Cook drilled him through the chest with a Winchester slug. Friar's brother, Art, was twice wounded but fired his revolver at Hughes and Cook. The two Rangers pumped one bullet apiece into Art Friar, who fell dead. (Author's collection.)

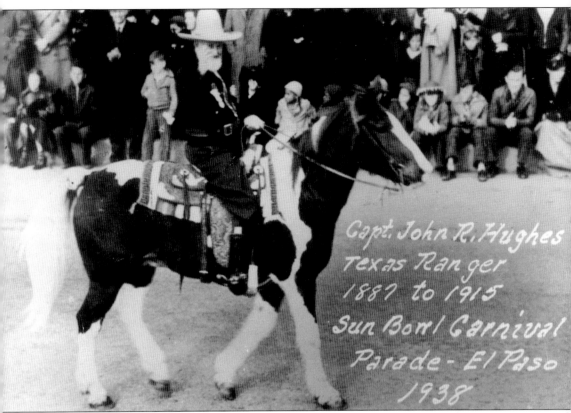

Capt. John R. Hughes
Texas Ranger
1887 to 1915
Sun Bowl Carnival
Parade - El Paso
1938

Late in his career, Hughes was appointed senior captain of the Texas Rangers, with headquarters in Austin. He became chair of the board of directors of the Citizens Industrial Bank of Austin. When he retired, in 1915, he had served as a Ranger and as a captain longer than any other man. Hughes never married, and in retirement, he lived in El Paso, where Company D was based through the years. He traveled a great deal and enjoyed riding in parades and making other public appearances. When he reached his early 90s, he moved to Austin to live with a niece. In ill health, he committed suicide in 1947 at the age of 92. He was buried in the Texas State Cemetery in Austin. (Author's collection.)

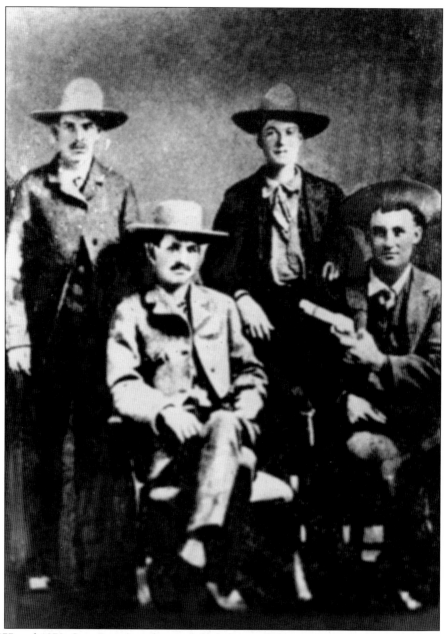

In 1877 and 1878, Sam Bass (standing at left) led several desperadoes in robbing at least seven stagecoaches and five trains. Bass had left Texas in 1876 to trail a herd of cattle to booming Dakota Territory. Soon, Bass and his partner, Joel Collins, turned to outlawry. After looting stagecoaches in the Black Hills, Bass and his henchmen robbed a train of $65,000. But, within several days, Collins and two other outlaws were hunted down and killed. Bass escaped to Texas and organized another gang. In the spring of 1878, the Sam Bass Gang staged four train holdups in the Dallas area. But the robbers snared little loot, and a widespread manhunt ensued. Although Bass next intended to rob a bank in Round Rock, gang member Jim Murphy betrayed the plan to Texas Rangers in return for leniency. (Courtesy Western History Collections, University of Oklahoma Library.)

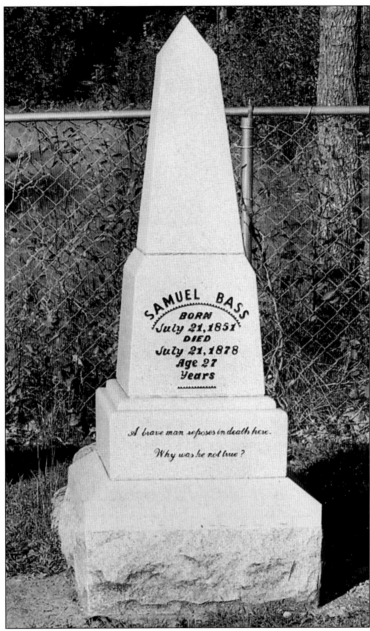

Round Rock was swarming with lawmen on Friday afternoon, July 19, when Sam Bass led Seaborn Barnes, Frank Jackson, and Jim Murphy from their camp west of town. The outlaws had already cased the town twice and decided to rob the bank on Saturday. Murphy dropped behind his companions, muttering something about his horse. Bass, Barnes, and Jackson entered a store near the bank, where two deputy sheriffs suspiciously accosted them. The outlaws gunned them down and headed for their horses. Texas Rangers and several citizens opened fire, and Barnes was killed by Ranger Dick Ware. Bass and Jackson galloped away, but Ranger George Harrell sent a slug through Sam's torso. The two outlaws escaped into the growing darkness, but Bass could not stay on his horse. Jackson rode on, while Bass was found on Saturday and died on Sunday, his 27th birthday. (Photograph by the author.)

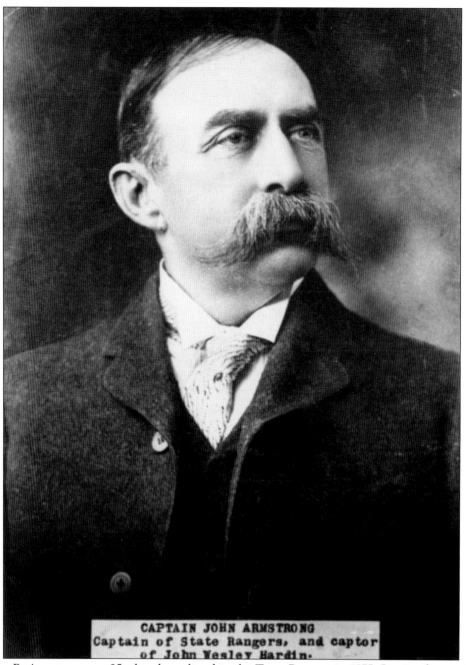

CAPTAIN JOHN ARMSTRONG
Captain of State Rangers, and captor
of John Wesley Hardin.

John B. Armstrong was 25 when he enlisted in the Texas Rangers in 1875. Serving first under famed border captain L.H. McNelly, he accompanied violent forays into Mexico and became known as "McNelly's Bulldog." In 1876, Armstrong, by now a sergeant, conducted a patrol into King Fisher's territory. Jumping an outlaw camp at midnight, Sergeant Armstrong and his men gunned down all four fugitives; three of the outlaws died and the fourth was hit four times. Promoted to lieutenant, Armstrong and Ranger Leroy Daggs rode to the Wilson County ranch of murderous John Mayfield. When Mayfield went for his guns, the two Rangers killed him on the spot. (Courtesy Western History Collections, University of Oklahoma Library.)

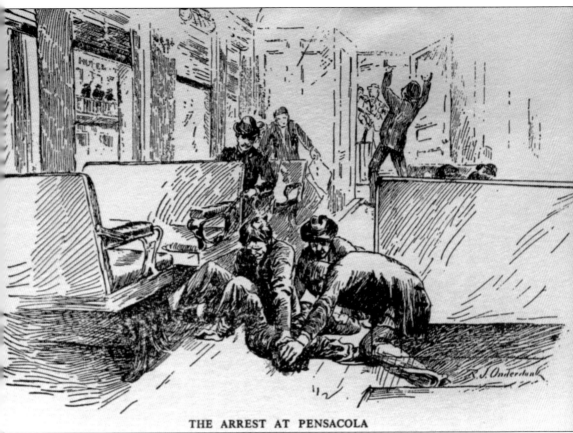

THE ARREST AT PENSACOLA

Attracted by a large reward, Lieutenant Armstrong combed the Gulf states in search of killer John Wesley Hardin, finally locating him in Florida. When the fugitive's train pulled into Pensacola, Armstrong—who held no legal authority in Florida—was waiting with a hastily assembled posse. Armstrong entered Hardin's coach and ordered Wes and his companions to surrender. Jim Mann, seated next to Hardin, pulled a revolver and shot a hole in Armstrong's hat. The Ranger coolly shot Mann in the heart. Hardin's revolver was caught in his suspenders, and Armstrong knocked him unconscious with his pistol barrel. Armstrong placed Hardin and three companions on a train to Texas. With the $4,000 reward, Armstrong left the Rangers and installed his large family on a 50,000-acre ranch in Willacy County. (From Hardin's autobiography, *Life of John Wesley Hardin, As Written by Himself*, 1896; pen and ink drawing by J. Onderdonk.)

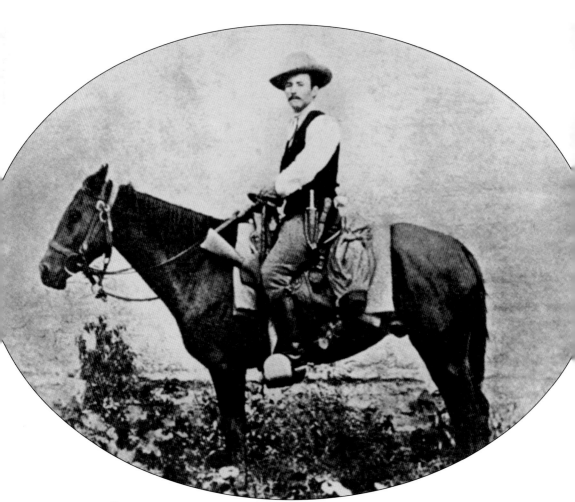

James B. Gillett was born in 1856 and raised in Austin, where he learned to ride and shoot. At 17, he left home to become a cowboy, but two years later, he enlisted as a Texas Ranger. For more than six years, he was embroiled in fugitive manhunts and skirmishes with Comanche warriors. In January 1877, Gillett led five other Rangers in pursuit of outlaw Dick Dublin, who once had cowboyed with Gillett. Closing in on a ranch hideout, Gillett pursued Dublin into a ravine. After a warning, Gillett fired a round from his carbine, hitting Dublin above the right hip. The bullet coursed upward through his body, killing him instantly. After leaving the Rangers, Gillett built up a 30,000-acre ranch near Marfa. (Author's collection.)

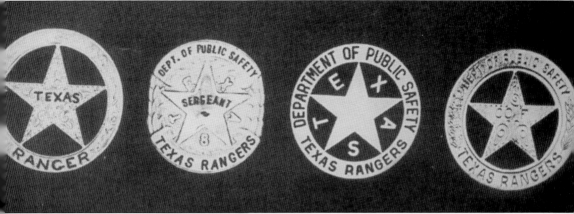

In the late 1800s, Texas Ranger badges were not provided by the state, but many officers carved their own out of Mexican silver coins, tin cans, wood, or even leather. These badges always featured a star, often surrounded by a circle—the famous "wagon wheel badge." Some badges had a shield surrounding the star. The words "Texas Ranger" or "State Ranger" were usually cut into the badge. Rangers frequently worked under cover and kept their badges inside a pocket until it was time to reveal their identity. After 1935, when the unit became part of the Department of Public Safety, Rangers wore highway patrol badges. But in 1967, the DPS changed the Ranger badge to a traditional star within a circle. (Courtesy Eakin Press.)

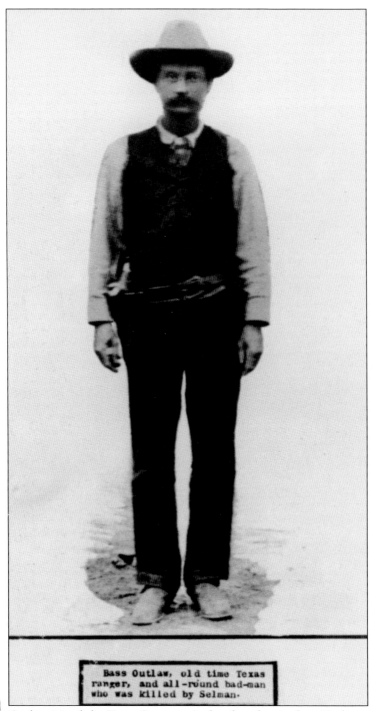

Bass Outlaw, old time Texas
ranger, and all-round bad-man
who was killed by Selman.

In 1885, Baz Outlaw joined the Texas Rangers. At five feet, four inches, Outlaw was feisty and
won rapid promotion to sergeant, although he proved to be a problem drinker. In 1889, while
drinking heavily, Outlaw shot a Mexican to death when the mine worker pulled a knife on him.
Later in the year, Outlaw was part of a four-man posse that ambushed and killed fugitives Alvin
and Will Odle. (Courtesy Western History Collections, University of Oklahoma Library.)

Discharged from the Rangers for being drunk while on duty, Baz Outlaw secured appointment as a deputy US marshal. In El Paso as a court witness on April 5, 1894, Outlaw spent the afternoon drinking and visiting Tillie Howard's sporting house. When Texas Ranger Joe McKidrict tried to settle him down, Outlaw shot him in the head and back. Constable John Selman drilled Outlaw in the chest. Outlaw put two slugs in Selman's leg but died four hours later on a prostitute's bed. (Author's collection.)

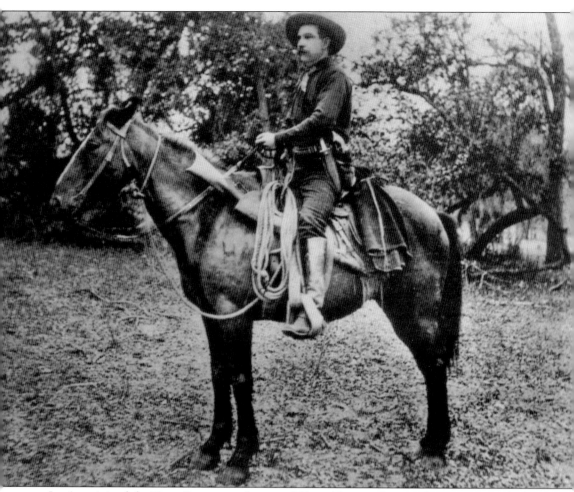

Ira Aten joined the Texas Rangers at the age of 20, and he soon became known as a crack shot. During his rookie year, 1884, two rustlers wounded one Ranger and killed another, Frank Sieber. But Aten wounded both rustlers with his Winchester, and soon, they were in custody. In 1887, Aten twice exchanged shots with outlaw Judd Roberts before finally killing him at a ranch hideout. On Christmas night 1889, Aten and three other officers ambushed Alvin and Will Odle, killing the outlaw brothers in the moonlight. In Dimmitt in 1891, Aten, no longer a Ranger, was denounced in public by the McClelland brothers, Andrew and Hugh, who began shooting at Ira. Aten halted the fight by wounding both brothers. (Author's collection.)

William Jesse "Bill" McDonald was born in Mississippi in 1852. His father was killed during the Civil War, and the family moved to Texas in 1866. As a young man, McDonald worked as a merchant, supplementing his income by serving as a peace officer. He was a deputy sheriff in two counties, deputy US marshal, and a special Ranger. His performance in law enforcement was impressive, and in 1891, Gov. James Hogg appointed him captain of Company B of the Frontier Battalion of Texas Rangers. In 1893, Captain McDonald and Sheriff John Matthews, who despised the Ranger, had a street shootout in Quanah. Both men were twice wounded, and Matthews died. In 1906, the year before he retired, Captain McDonald and his men shot their way out of an ambush near Rio Grande City. (Right, author's collection; below, photograph by the author.)

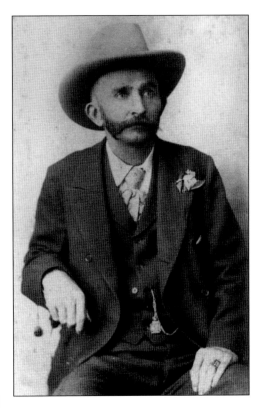

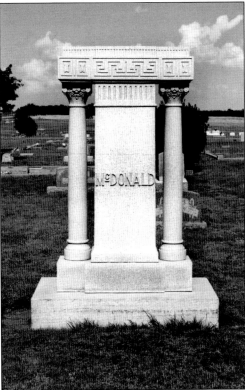

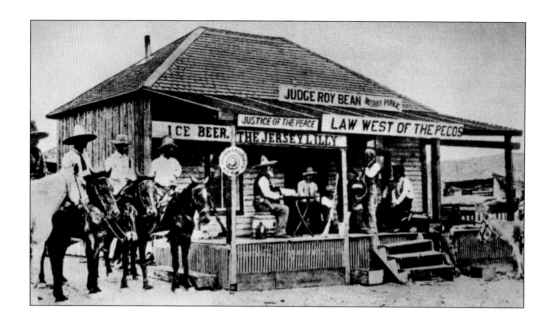

A different law officer was the legendary Judge Roy Bean, popularly known as the "Law West of the Pecos." For two decades, Bean was a justice of the peace at Langtry, a hardscrabble village he named for singer Lily Langtry. He dispensed his version of the law from his saloon. During one inquest, a revolver and $40 were found on a corpse. Judge Bean fined the deceased $40 for carrying a concealed weapon and confiscated the pistol, for use by the court. Bean freed an Irishman accused of killing a Chinese railroad worker after searching his single law book and concluding that the statutes "did not say it was against the law to kill a Chinaman." (Both, author's collection)

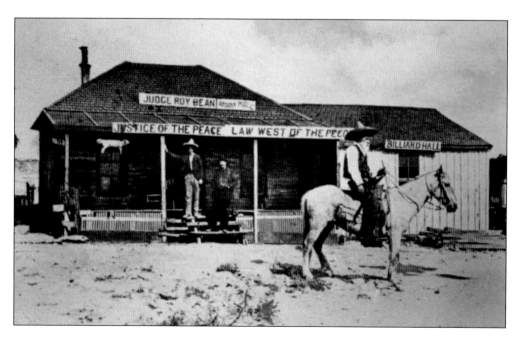

Five

BLOOD FEUDS

There were more blood feuds in Texas than in any other state or territory. The Regulator-Moderator War in 1840–1844 produced almost 40 dead, setting a high standard for future Texas feudists. The Lee-Peacock Feud during Reconstruction was a vicious four-year conflict that resulted in the bushwhacking deaths of both faction leaders.

The large-scale Sutton-Taylor Feud featured the murder of Bill Sutton in front of his wife and baby daughter. But there apparently was little other Sutton involvement. Instead, the Taylor clan seems to have led a vast crime ring involving 200 criminals committing nefarious deeds across a 45-county area. For more than two decades, there were robberies, rustling, and gunplay.

In 1875, the Hoo Doo War, or Mason County War, pitted Anglos against German-Texans, with cattle rustling and shootings rampant until Maj. John Jones of the Texas Rangers arrived to quiet the difficulties. Major Jones was needed again two years later in nearby Lampasas County, arranging a truce to halt the Horrell-Higgins Feud. But vendettas were commonplace in the wake of feuds, and more men were killed after the "end" of the Horrell-Higgins conflict than were slain during the feud.

The Jaybird-Woodpecker Feud inspired superlative heroism from Tom Smith. And there was widespread feuding between cattlemen and sheepherders as they competed for use of Texas ranges. The last old-fashioned feud in Texas, the Johnson-Sims Feud that raged from 1916 to 1918, took place three quarters of a century after the Regulator-Moderator War of frontier East Texas.

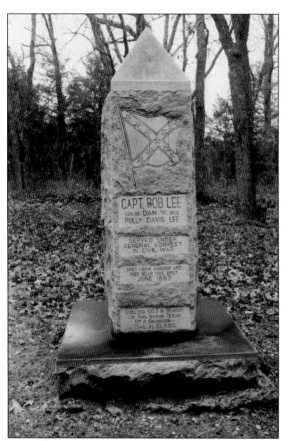

The Lee-Peacock Feud erupted in 1867 in the vicinity of Pilot Grove. Lewis Peacock guided a faction of Reconstruction Union League gunmen against former Confederates led by Capt. Bob Lee. Wilderness bushwhackings produced three fatalities, and in April 1868, Peacock was wounded during a skirmish in Pilot Grove. Bob Lee led another ambush two months later that resulted in the death of three of Peacock's men. (Photograph by the author.)

In December 1868, Peacock rode at the head of a few of his men and a detachment of Union soldiers in a search for Bob Lee. Near Farmersville, however, Lee sprang another ambush. One of the soldiers was killed, a Peacock ally was wounded, and Peacock narrowly escaped. But in June 1869, Lee finally was ambushed and slain near his home. (Photograph by the author.)

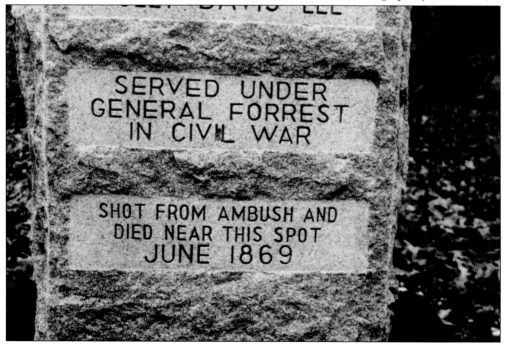

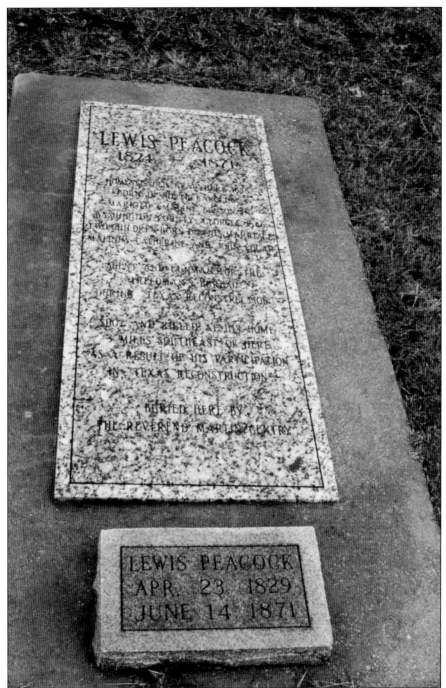

Following the death of Bob Lee, there were further revenge killings, and Lewis Peacock began to spend most of his time in hiding. On June 12, 1871, however, two friends of Lee, Dick Johnson and Joe Parker, spotted Peacock sneaking back to his Pilot Grove home. Johnson and Parker set a vigil, which lasted throughout the night. At dawn, Peacock emerged to get firewood, and Johnson and Parker opened fire. Peacock was mortally wounded, and his assassins fled the scene. (Photograph by the author.)

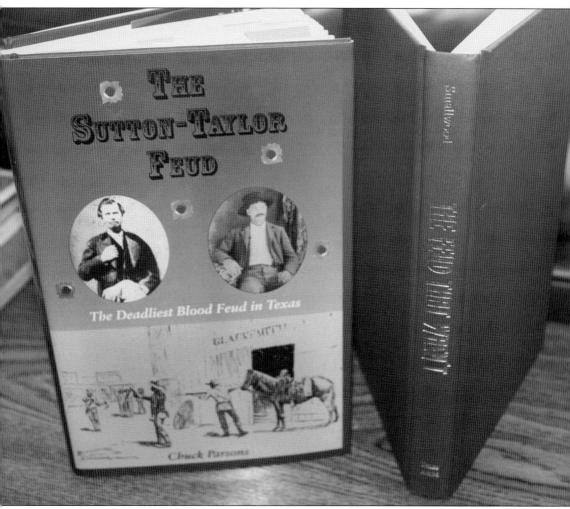

In a case of feuding books, *The Sutton-Taylor Feud*, by veteran outlaw-lawman author Chuck Parsons (University of North Texas Press, 2009), and *The Feud That Wasn't*, by noted Reconstruction researcher James Smallwood (Texas A&M University Press, 2008), present opposing viewpoints about the long, murderous Sutton-Taylor "Feud." Parsons provides great detail about the factions and incidents of what he subtitles *The Deadliest Blood Feud in Texas*. Smallwood points out, however, that there was little Sutton involvement. He insists that there was a vast, loosely organized crime ring dominated by the large Taylor clan. Smallwood lists 197 men involved in the ring, including 11 Taylors and other desperados such as Wes Hardin, Bill Longley, and Killin' Jim Miller. Rustling, robberies, and other crimes occurred in 45 counties. (Photograph by the author.)

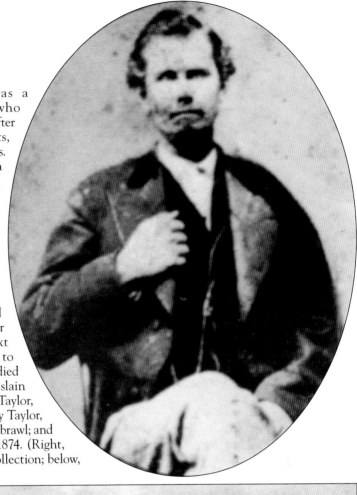

Bill Sutton (right) was a Confederate veteran who clashed with the Taylors. After several shooting incidents, Sutton decided to leave Texas. At the port of Indianola (below), Sutton, along with his wife, child, and a friend, Gabe Slaughter, boarded a steamboat bound for New Orleans. But brothers Jim and Bill Taylor hurried onto the boat and opened fire. Before his horrified wife, Sutton dropped to the deck with bullets in his head and heart, and Slaughter died beside him. The next year, Jim Taylor was shot to death. Other Taylors who died violently were Hays Taylor, slain in an 1867 ambush; Buck Taylor, killed the next year; Doboy Taylor, shot three times in an 1871 brawl; and Rufus Taylor, lynched in 1874. (Right, courtesy Chuck Parsons collection; below, author's collection.)

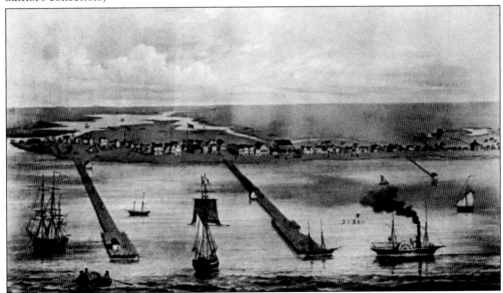

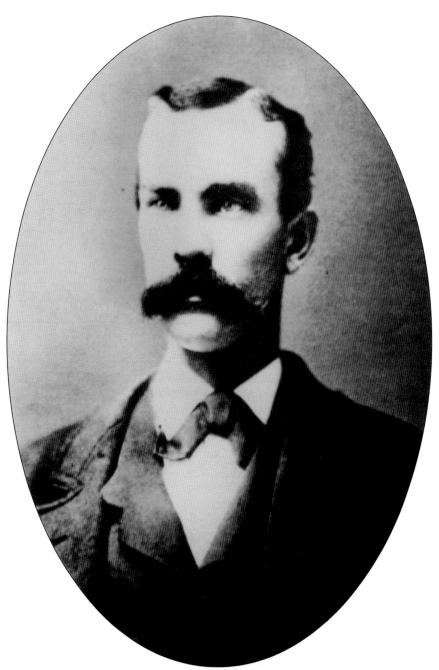

The Mason County War, also called the "Hoo Doo" War, erupted in 1875. Essentially a clash between Anglos and Germans, the conflict was aggravated by cattle thefts. There were several shootings, as well as mob violence. A key figure was Scott Cooley, a former Texas Ranger who had turned to farming and ranching. When a close friend was killed in Mason County, Cooley came to the area seeking vengeance, gunning down three men in separate incidents. John Ringo (pictured) also killed a man. Texas Rangers under Maj. John Jones intervened to arrange a truce. Cooley and Ringo were arrested but were then broken out of jail. Cooley died under mysterious circumstances, while Ringo later brought his guns to Arizona. (Author's collection.)

In Hood County, the Mitchell and Truitt families feuded in 1874 over a land dispute, and two of the Truitts died of wounds. The next year, county officials legally hanged patriarch Cooney Mitchell in Granbury. Mitchell's son, Bill, blamed the Reverend James Truitt (right), a young minister whose testimony was the key to the conviction. After nursing his grudge for more than a decade, Bill Mitchell murdered Truitt in 1886 at his home in Timpson. Truitt's grave is shown below. (Right, author's collection; below, photograph by the author.)

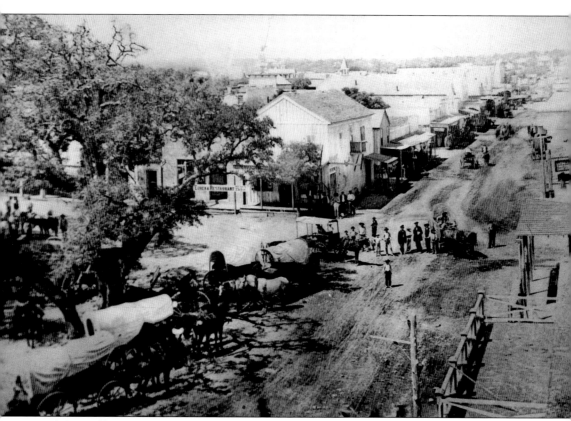

The Horrell-Higgins Feud swept across Lampasas County in 1877. The Horrell brothers were rustlers and chronic troublemakers, and in 1876, Merritt Horrell stole a yearling from the ranch of Pink Higgins. Higgins retrieved the stolen yearling and filed charges. When Horrell was exonerated, Pink vowed to seek justice with his Winchester. But Merritt arrogantly stole several more cattle. On Saturday, January 20, 1877, Pink found Merritt drinking in the same saloon (second door to the left) where the Horrells had gunned down four members of the Texas State Police in 1873. Pink Higgins leveled his Winchester and said, "Mr. Horrell, this is to settle some cattle business." Pink's first round knocked Horrell to the floor. Merritt stood up shakily, but Higgins triggered three more bullets into him. (Courtesy Standard Studio, Lampasas.)

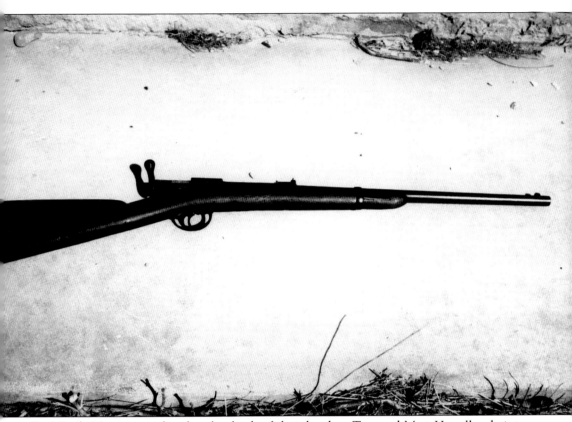

On March 26, two months after the death of their brother, Tom and Mart Horrell rode into Lampasas for a scheduled court appearance. Pink Higgins and a few of his men set an ambush about five miles east of Lampasas at a stream later called "Battle Branch." When Tom and Mart stopped to water their mounts, the hidden gunmen opened fire. Tom was knocked out of the saddle by a bullet in the hip, and Mart suffered a flesh wound in the neck. His horse bolted, but Mart controlled the animal and turned back to his fallen brother. Brandishing his Winchester, Mart drove off the ambushers with a one-man charge. Mart managed to carry Tom to a nearby house before galloping into town for help. (Photograph by the author of a Horrell rifle on display at the Keystone Square Museum in Lampasas.)

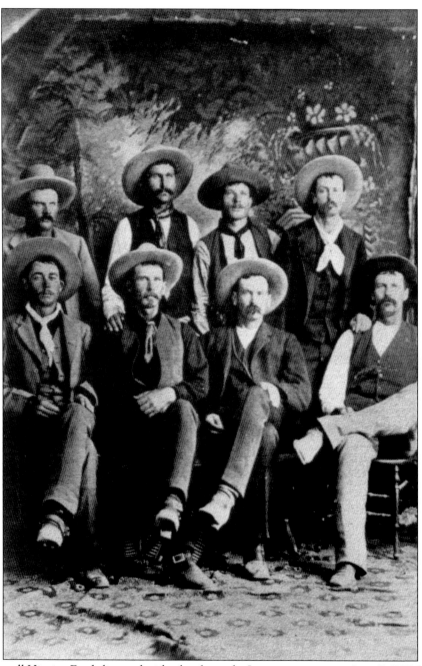

The Horrell-Higgins Feud climaxed with a battle on the Lampasas square on June 7, 1877. Higgins (seated, far right) and some of his allies had legal business in town. Members of his trail crew included feud allies Bob Mitchell (beside him) and Alonzo Mitchell (behind him). A large Horrell faction was in town, and Tom Horrell was first to spot the approaching Higgins riders. Bill Wren, a future sheriff, was wounded, and Bob Mitchell helped him inside a building. Bob's brother, Frank Mitchell, spotted Mart Horrell and Jim Buck Miller advancing. Frank drilled Miller in the chest, but he was killed by a return shot from Mart Horrell. With one fatality on each side, a cease-fire finally was arranged. (Courtesy Standard Studio, Lampasas.)

Maj. John P. Jones and a squad of Texas Rangers imposed a truce on the Horrell and Higgins factions. But vendettas often followed feuds, and for more than a year, night riders struck Horrell supporters in at least three violent assaults. And in May 1878, when a popular Bosque County merchant was robbed and murdered, Mart and Tom Horrell were implicated and jailed in Meridian. On December 15, 1878, a mob of more than 100 masked men broke into the jail and gunned down Mart and Tom in their cell. The brothers were buried in Lampasas. There were seven Horrell brothers. The oldest died in the Civil War, and five of the remaining six were killed by gunfire. (Photograph by the author.)

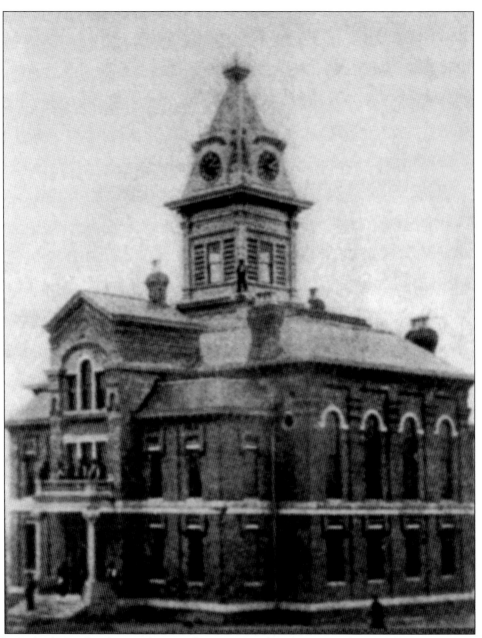

The Jaybird-Woodpecker Feud erupted in Fort Bend County in 1888, waged by political and racial factions that derisively called each other "Jaybirds" and "Woodpeckers." For several months, there were ambushes and brawls, and Texas Rangers were sent to quell the violence. But killings continued on both sides, and at dusk on August 16, 1888, the "Battle of Richmond" exploded in front of the courthouse (pictured). Sheriff J.T. Garvey was escorting a Jaybird prisoner to the courthouse when he was cut down by a volley of fire. Deputy sheriffs Tom Smith and H.S. Mason drew their revolvers, but Mason fell wounded. Smith opened fire, emptying his gun and then using the revolvers of his fallen comrades. Then, two Texas Rangers ran out of the courthouse, and one was hit while the fallen lawmen were carried inside. (Courtesy Fort Bend County Historical Museum, Richmond.)

The Battle of Richmond produced eight casualties, including four dead. The next day, Gov. Sul Ross (right) and two militia units arrived to restore order, staying in Richmond for several days. Tom Smith's heroic stand to provide covering fire established his reputation as a lethal shootist. He accepted the position of city marshal of Taylor, where he was reputed to have killed two men in the line of duty. Perhaps feeling that he could earn more money by collecting fees and rewards while working as a deputy US marshal, Smith left his family in Taylor and centered his professional activities in Paris, the location of the headquarters (below) of the Eastern Judicial District of Texas. (Right, author's collection; below, courtesy Aiken Regional Archives at Paris Junior College.)

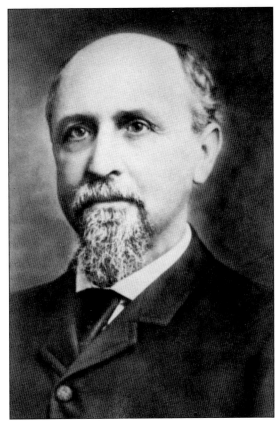

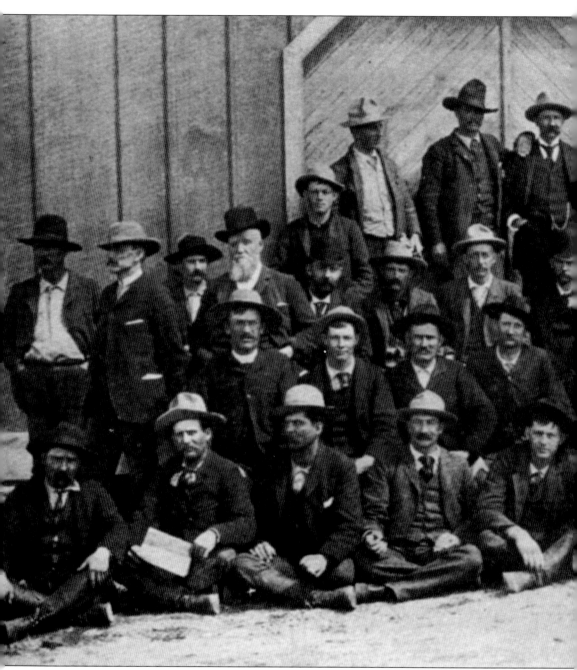

Deputy US marshals and posse men stayed near the federal courthouse at Paris, hoping for the opportunity to serve warrants, thereby collecting arrest fees, travel expense, and rewards. In 1891, the highly regarded deputy US marshal Tom Smith was hired by the Wyoming Stock Growers Association to assist with the range difficulties. These problems soon exploded into the Johnson County War, the West's most notorious range conflict. Wyoming cattle barons decided to launch an expedition into Johnson County to kill or arrest rustlers. Deciding to import a number of Texas gunmen, they dispatched Tom Smith (standing at left, white shirt, dark hat) back to Texas to recruit men who were willing to use their guns in Wyoming. In Paris, Tom Smith recruited

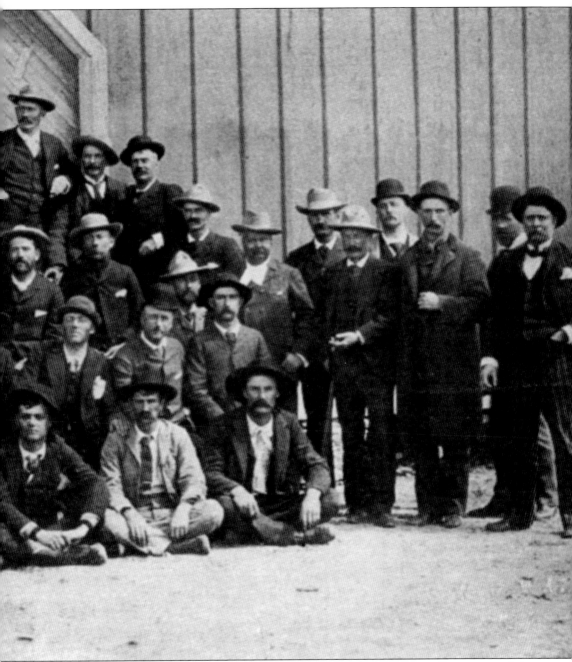

more than a score of deputy marshals and posse members. Smith promised excellent wages, while suggesting that the intent of the expedition was to round up rustlers and place them into the legal system. Smith and his recruits traveled by train to Cheyenne, where they were presented with new rifles before marching north to Johnson County. The invaders were more than 50 strong, including big cattlemen, WSGA stock detectives such as Frank Canton (formerly Joe Horner from Texas), and the Texas gunmen. But following a four-day battle at the TA Ranch against 400 citizens, the invaders surrendered. In a famous group photograph, the Texans occupy the bottom two rows. (Courtesy Jim Gatchell Museum, Buffalo, Wyoming.)

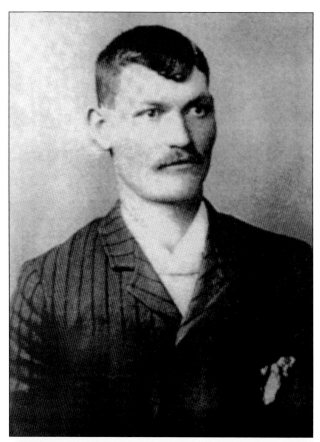

The most heroic opponent of the Johnson County invaders was another Texas expatriate, cowboy-gunman Nate Champion. Cornered by more than 50 invaders at the KC Ranch, Champion courageously stood them off for hours. When his cabin was set on fire, he sprinted for safety with guns blazing, but he was gunned down by Texas adversaries, who were paid a bonus. (Courtesy Jim Gatchell Museum, Buffalo, Wyoming.)

Thanks to legal maneuvers by a superb team of lawyers, the Johnson County invaders were released from custody. In the melee, two Texans had died from gunshot wounds. The rest returned to Texas. Tom Smith resumed his duties as a deputy US marshal. But on a train in 1892, he was shot above the eye by a fugitive. Tom Smith was buried in Taylor. (Photograph by the author.)

THOMAS CALTON SMITH
NOV. 5, 1892

There was trouble on Texas ranges between cattlemen and sheepherders. Sheep were cursed by cowmen as "hoofed locusts," "stinkers," "maggots," and "baaa-a-ahs." Cowboys liked to say, "There ain't nothing dumber than sheep except a man who herds 'em." Cowmen also derisively referred to sheepherders as "mutton punchers" and "lamb lickers." Killin' Jim Miller reportedly was hired by Texas cattlemen at $150 per killing. "I have killed eleven men that I know about," he admitted to a Fort Worth acquaintance, before adding with disdain, "I have lost my notch stick on sheepherders I've killed out on the border." (Author's collection.)

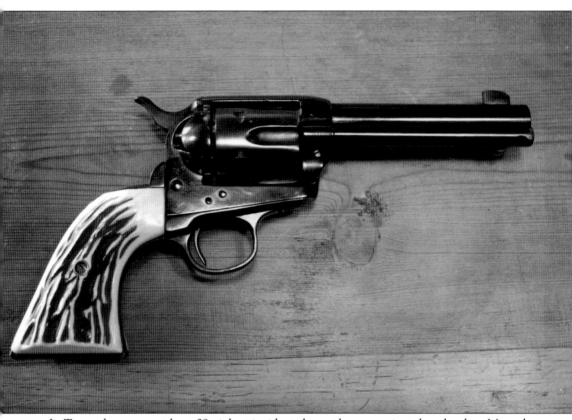

In Texas, there were at least 29 violent incidents by cattlemen against sheepherders. More than 3,200 sheep were killed, along with four sheepherders and two cowboys. In 1889, an out-of-work cowboy persuaded Burnet County sheep rancher Andy Feild to hire him as a herder. But the cowboy ignored his duties and was fired. Before leaving the ranch, the cowboy rode up to accost Feild. Dismounting, he cursed Feild, then drew his revolver and snapped off a shot. But Feild had taken the precaution of placing the Colt seen here in his waistband. Feild charged, shooting the cowboy in the elbow, chest, and head. When the Feild sheepdog licked the wounds, the cowboy moaned but soon died. (Courtesy Andy Field.)

Six

GUNFIGHTER TOWNS

Dodge City, Tombstone, and Deadwood attained notoriety as gunfighter haunts, complete with saloon shootouts and street battles. The most famous of all gunfights took place at Tombstone's OK Corral, in which the Earp faction killed three adversaries.

But in Lampasas, site of numerous gunfights during the 1870s, four members of the Texas State Police were gunned down in an 1873 saloon battle. It was the only Old West shootout in which four police officers were fatally wounded. There also were four fatalities in the 1886 Tascosa clash, which became known as "the Big Fight." The four victims were buried in Tascosa's Boot Hill, one of the most famous boot hills in the West.

Tascosa's red-light district was called "Hogtown," and there were fights and killings there. Fort Worth denizens enjoyed the illicit pleasures of "Hell's Half Acre," just south of downtown. Austin's "Guy Town" was just north of the Colorado River. The cowboys of Amarillo roistered in the "Bowery District," while the crown jewel of El Paso's red-light neighborhood was Tillie Howard's sporting house.

Gunplay was no stranger to any of these rough districts. Indeed, three officers were shot—two fatally—at Tillie Howard's. John Wesley Hardin, John Selman, and Dallas Stoudenmire also were killed in El Paso shootouts. There was a gunfight in Fort Worth between noted shootists Luke Short and "Longhaired Jim" Courtright. Ben Thompson and King Fisher were slain together in San Antonio. Early Waco saw enough gunplay to earn the nickname "Six-Shooter Depot."

Among the bloodiest shootouts in the West were bank holdups. In 1894, Bill Dalton and three confederates raided the First National Bank of Longview. During the robbery, five citizens were shot, including two fatally, and one outlaw was killed. Dalton was tracked down and shot dead. In many Texas towns, shootists needed to keep their guns loaded.

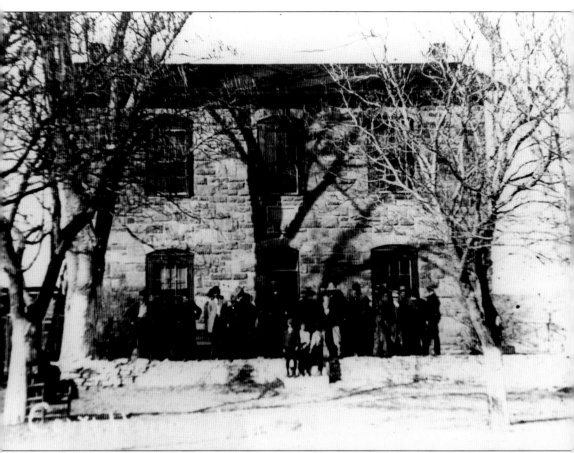

Tascosa's two-story rock courthouse was built in 1884, when the cattle town was known as the "Cowboy Capital of the Panhandle." Just as accurately, Tascosa could have been branded the "Gunfighter Capital of the Panhandle." During the 1880s, there were 10 gunfights in Tascosa. Billy the Kid, Pat Garrett, Henry Brown, and Temple Houston were among the lethal gunfighters who rode Tascosa's dusty streets. In addition to the adobe saloons along Main Street, a cluster of dives a quarter of a mile east became known as "Hogtown," featuring the charms of such sporting women as Homely Ann, Gizzard Lip, Rowdy Kate, Box Car Jane, Slippery Sue, and Frog Lip Sadie. There were at least four shootouts in Hogtown. (Courtesy Panhandle-Plains Historical Museum, Canyon.)

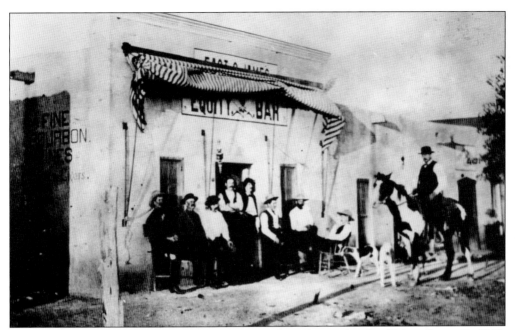

Tascosa's most famous saloon, the Equity Bar, stood on the north side of Main Street. In 1881, Sheriff Cape Willingham rounded the corner at left and blasted troublemaker Fred Leigh out of the saddle with both barrels of his shotgun. Inside the building in 1889, Sheriff Jim East killed gambler Tom Clark in Tascosa's final shootout. (Courtesy Panhandle-Plains Historical Museum, Canyon.)

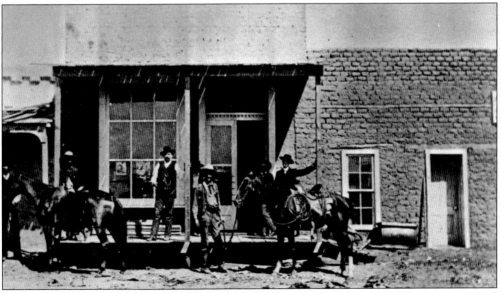

The Howard and McMasters general store stood on the northeast corner of Tascosa's principal intersection. Jules Howard clashed with saloonkeeper Bob Russell, who was his own best customer. One morning early in March 1881, Russell, already inebriated, stalked into the Howard and McMasters store. Jules Howard stood with his gun drawn. Russell fumbled for his revolver and triggered one wild shot, but he was drilled in the chest, head, and trigger finger. (Courtesy Panhandle-Plains Historical Museum, Canyon.)

Tascosa's deadliest explosion of violence was an 1886 shootout known as "the Big Fight." There were hard feelings against cowboys from the nearby LS Ranch, and a post-midnight revelry resulted in an ambush at Tascosa's main intersection. One LS cowboy was shot dead in the street from the darkened Jenkins and Dunn Saloon. His three comrades charged into the saloon, but two of them were killed, along with a bystander. (Courtesy Panhandle-Plains Historical Museum, Canyon.)

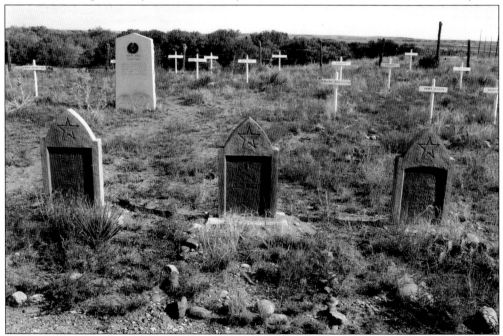

The next day, four coffins were built and the corpses were dressed in new black suits. A mass funeral was held in the afternoon, and the entire populace of Tascosa, along with area cowboys, formed a half-mile procession to Boot Hill. The LS Ranch provided headstones for its three dead riders. (Photograph by the author.)

In the fall of 1878, Billy the Kid (pictured) and four other New Mexico fugitives moved a herd of stolen horses to the Tascosa area. During the next few weeks in Tascosa, Billy and his companions gambled and raced horses and shot at targets. During a money match, the Kid outshot Temple Houston. In November, the Kid and Tom O'Folliard returned to New Mexico, where they were later slain. (Author's collection.)

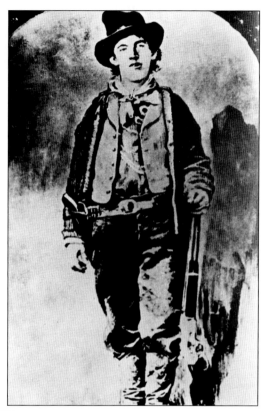

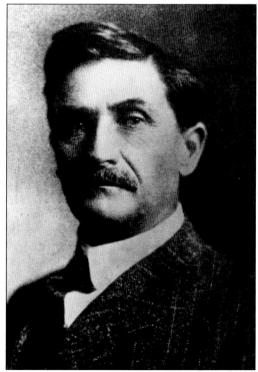

Three years after Billy the Kid returned to New Mexico, he was killed by Sheriff Pat Garrett. Garrett claimed his first shooting victim in the Texas Panhandle in 1876, while hunting buffalo. During a fistfight in camp, a skinner ran with an axe toward Garrett, who had to shoot him. In later years, Garrett ran a horse ranch at Uvalde and was a customs collector in El Paso. After Garrett's murder in New Mexico, the assassin was rumored to be Killin' Jim Miller. (Courtesy Arizona Historical Society Library.)

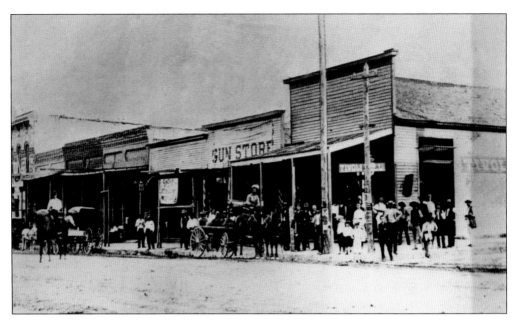

The frontier community of Fort Worth took shape around a military outpost founded in 1849. When the Army moved farther west four years later, the old parade ground became the town square. After the Civil War, Fort Worth was an important stop on the Chisholm Trail. Cowboys frolicked in saloons and gambling halls. In the south part of town, a red-light district developed, known as "Hell's Half Acre." There were numerous shootouts, including the classic face-to-face gunfight between Luke Short and Longhaired Jim Courtright. And Killin' Jim Miller moved to town. His wife ran a boardinghouse, which he left from time to time to go on lethal errands. Shown above is an 1876 street scene; below, the 1878 courthouse is on the skyline at center of the panorama. (Both, courtesy Fort Worth Courthouse.)

Timothy Isaiah "Longhaired Jim" Courtright served as city marshal of Fort Worth from 1876 to 1879. Later, he formed a private detective firm, the T.I.C. Commercial Agency. But the agency's primary activity was a protection racket by which Fort Worth's gambling joints were "policed" in return for a piece of the action. (Courtesy Western History Collections, University of Oklahoma Library.)

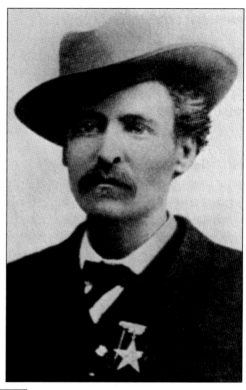

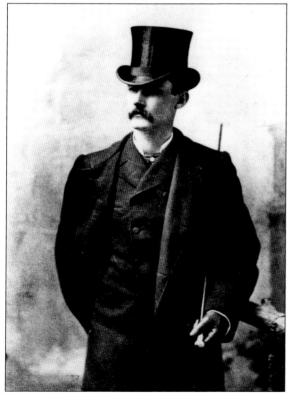

Luke Short was a professional gambler who killed Charles Storms in Tombstone's Oriental Saloon. Short had other gunfights in Dodge City and Leadville. A dapper dresser, Short had his right pants pocket lined with leather to hold his revolver. By 1887, he had bought an interest in Fort Worth's White Elephant Saloon, soon coming in conflict with Jim Courtright and his T.I.C. shakedown efforts. (Courtesy Kansas State Historical Society, Topeka.)

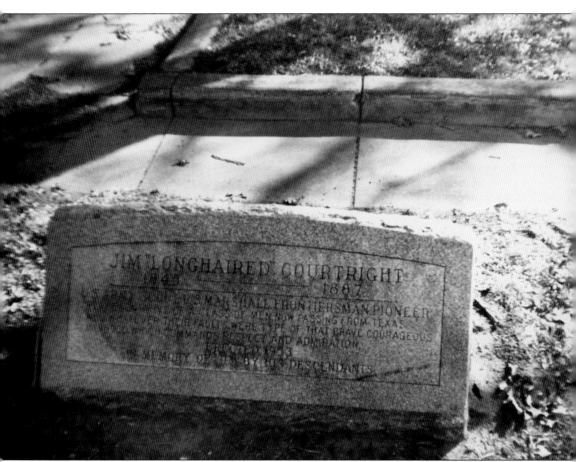

Trouble between Luke Short and Jim Courtright came to a head in Fort Worth on February 8, 1887, soon after Courtright threatened the gambler. Accompanied by Bat Masterson, Short encountered Courtright at a shooting gallery. Courtright pulled one of his revolvers and jammed it into Short's mid-section. But the hammer caught on Short's watch chain, and Short snapped out his own pistol. He emptied his gun rapid-fire: the first slug smashed the cylinder of Courtright's drawn six-gun; two shots went wild; and three bullets tore into Courtright's right thumb, right shoulder, and heart. Courtright collapsed and died within minutes. He was buried at Fort Worth's Oakwood Cemetery. (Photograph by the author.)

A gambling dispute drew Luke Short into his final gunfight in Fort Worth on December 23, 1890. Saloon owner Charles Wright ambushed Short with a shotgun blast from behind. Short was hit in the left leg, but he opened fire with his revolver. Wright managed to escape, but one of Short's bullets broke his wrist. Short died of dropsy in 1893 at the age of 39. (Courtesy author's collection.)

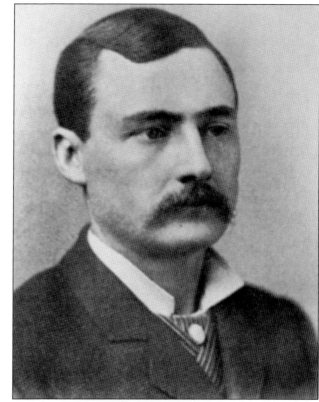

Luke Short was buried in Oakwood Cemetery, not far from Jim Courtright, his most famous victim. Several years later, Short and Courtright were joined at Oakwood by Killin' Jim Miller. (Photograph by the author.)

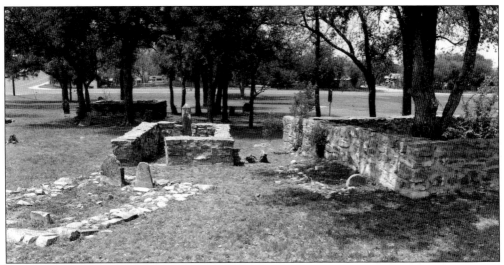

For more than two decades, Lampasas was the scene of saloon shootouts and street battles. In 1855, the year the new townsite was surveyed, Bob Willis fatally wounded a man named Nixon. Several years later, Willis was assassinated at his home, probably a revenge killing. Early shooting victims were buried in Pioneer Cemetery. (Photograph by the author.)

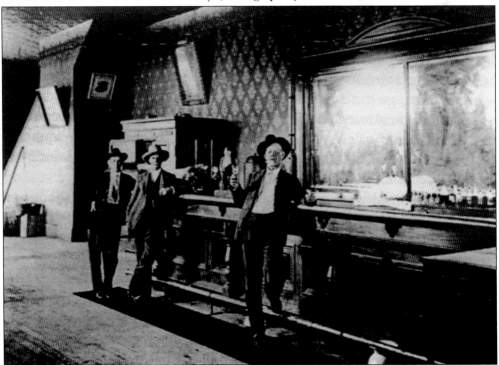

During the 1870s, a series of deadly shootings erupted in the saloons of Lampasas. In 1872, Sheriff Shade Denson tried to arrest the drunken Short brothers, Mark and Wash, but they grappled with him. Mark shot the sheriff in the side and escaped the scene with his brother. Denson survived but carried the bullet the rest of his life. Four years later, Denson's oldest son, Sam, encountered Mark Short in another Lampasas saloon and killed him with three revolver bullets. (Courtesy Keystone Square Museum, Lampasas.)

The cell shown above, from the 1870 Lampasas County jail, housed shootists as well as a succession of other troublemakers. In 1876, John Ringo and Scott Cooley, arrested during the Mason County War, were incarcerated in the Lampasas jail, but they were soon broken out by 15 armed riders. Also in 1876, county attorney B.F. Hamilton and Newton Cook traded shots on the town square. After shooting himself in the hand with his derringer, Hamilton darted for cover among the live oak trees. The square was also the scene of a pitched battle during the Horrell-Higgins Feud. Higgins began the feud by killing Merritt Horrell in Jerry Scott's Matador Saloon on the square, also the site of Sheriff Shade Denson's shooting. And, on March 4, 1873, four members of the state police entered the saloon to arrest the Horrell brothers. All four were slain. It was the only gunfight in which four Western lawmen were killed. The saloon table, chairs, and whiskey jug (below) are preserved by the Keystone Square museum. (Both photographs by the author.)

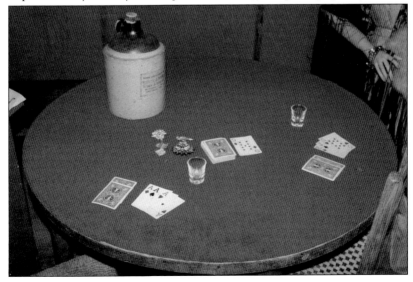

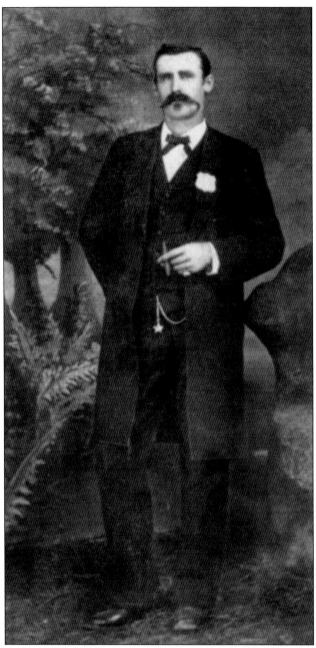

In April 1881, booming El Paso appointed a new city marshal. Tall, rangy Dallas Stoudenmire patrolled the teeming streets of El Paso with a brace of revolvers tucked inconspicuously under his coat in a pair of leather-lined hip pockets. He also carried a snub-nosed revolver as a hideout gun. Wounded in combat during the Civil War, Stoudenmire served as a Texas Ranger and was involved in at least three gunfights. On April 14, 1881, a gun battle exploded on an El Paso street. Marshal Stoudenmire charged onto the scene with two guns blazing. In the melee, three men died, two by Stoudenmire's guns. Three nights later, Bill Johnson, a drunken former city marshal, tried to ambush Stoudenmire. But Stoudenmire and his brother-in-law, Doc Cummings, pumped eight slugs into Johnson. (Author's collection.)

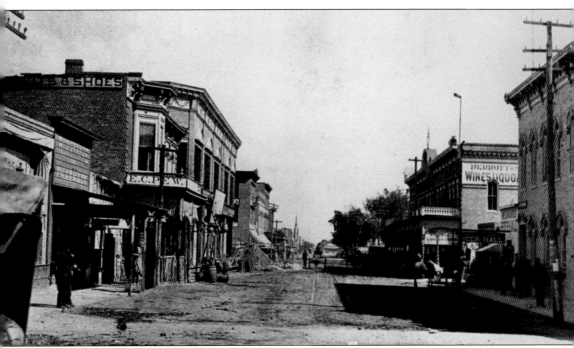

Marshal Stoudenmire soon proved to be a problem drinker, often firing his guns in the dead of night. Censured by the city fathers, Stoudenmire resigned after a year in office and was replaced by his deputy, Jim Gillett. Stoudenmire continued to drink and quarrel with the Manning brothers, Jim, Frank, Doc, and John. On September 18, 1882, trouble erupted in a saloon shootout. Doc Manning triggered the first shot, sending a bullet through Stoudenmire's arm and into his chest. Doc charged his reeling opponent, but Stoudenmire shot him in the arm with his belly gun. As the two men grappled, Jim Manning ran up and shot Stoudenmire behind the right ear. Dallas Stoudenmire was 36. (Author's collection.)

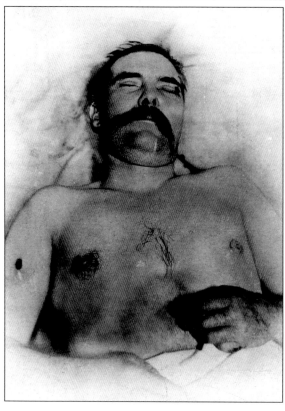

Wes Hardin served 17 years in the Texas State Penitentiary in Huntsville. While in prison, he studied for the bar. Sadly, less than two years before his release, his long-suffering wife died. Freed in February 1894, Hardin lived briefly in Gonzalez with his three children. He soon moved westward to Junction, where he married a young girl, who left him on the day of their wedding. Hardin opened a law office in El Paso. Drinking heavily, he quarreled with local lawmen John Selman and John Selman Jr. On August 19, 1895, while Hardin was gambling at the Acme Saloon, old John Selman stepped inside and shot him in the head. Selman walked to the fallen Hardin and drilled him twice more. John Wesley Hardin was 42. (Above, author's collection; left, courtesy Western History Collection, University of Oklahoma Library.)

When John Selman turned up in El Paso in 1888, he was pushing 50 and brought a reputation as a rustler and deadly gunman. In 1892, the formidable Selman won election as city constable of wide-open El Paso. At Tillie Howard's sporting house in 1892, Constable Selman killed a drunken Baz Outlaw, who had just slain Texas Ranger Joe McKidrict and wounded Selman. Selman was forced to use a cane for the rest of his life. In 1895, after a simmering feud, he killed legendary gunfighter Wes Hardin in the Acme Saloon. The following year, on April 5, 1896, a drunken Selman abrasively quarreled with noted lawman George Scarborough, who pumped slugs into his neck, hip, knee, and side. Selman was 56. (Right, courtesy Leon Metz; below, photograph by the author.)

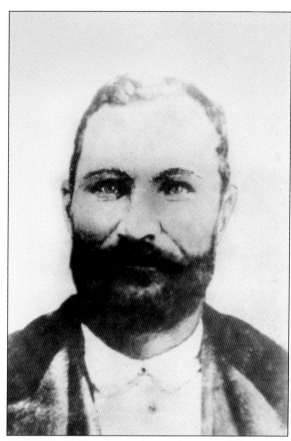

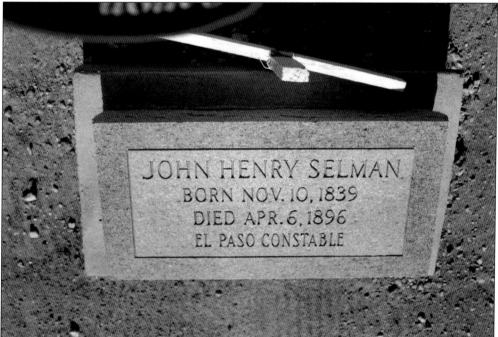

JOHN HENRY SELMAN
BORN NOV. 10, 1839
DIED APR. 6, 1896
EL PASO CONSTABLE

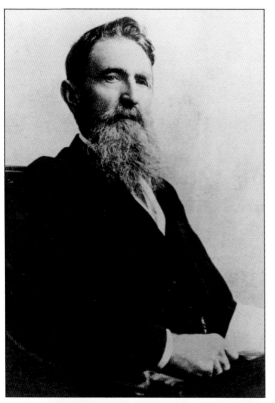

In the 1860s and 1870s, Waco was dotted with saloons, gambling houses, and bordellos, and there was enough gunplay to give the town the nickname "Six-Shooter Depot." By the 1890s, the forces of civilization seemed to prevail. But within four months in 1897–1898, nine casualties resulted from shootouts triggered by combative Civil War veteran Judge George B. Gerald. (Courtesy the Texas Collection, Carroll Library, Baylor University.)

As a colonel commanding a Mississippi regiment, George Gerald was wounded four times in combat, permanently crippling his left arm. He moved his family to Texas in 1869, settling in Waco during the heyday of Six-Shooter Depot. He served eight years as county judge, once strapping on a gun belt to personally wreck a gambling hall. In 1897, Judge Gerald feuded publicly with newspaper editor J.W. Harris, a dispute that exploded in front of Waco's Old Corner Drug Store. (Courtesy Texas Collection, Carroll Library, Baylor University.)

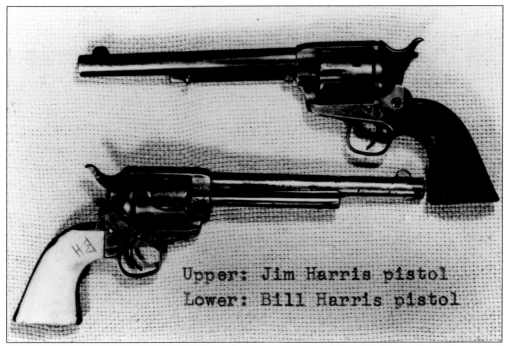

Upper: Jim Harris pistol
Lower: Bill Harris pistol

On November 19, 1897, J.W. Harris was at the cigar counter of the Old Corner Drug Store, and his brother Bill stood across the street, when Judge Gerald drove up in a buggy. When Gerald approached the drugstore, J.W. shot him in his crippled arm, but the judge drilled Harris in the throat. Bill Harris shot Judge Gerald in the back. A policeman grappled with Bill, but Gerald reached in and shot him in the head. Both Harris brothers died, and Judge Gerald lost his crippled arm. (Courtesy Texas Collection, Carroll Library, Baylor University.)

Judge Gerald was a friend of William C. Brann (pictured), a controversial writer and lecturer from Waco. On April 2, 1898, Brann and his manager, W.H. Ward, were walking near the Old Corner Drug Store when a local lawyer, Tom Davis, stepped up and sent a .45 slug into Brann's back. Brann whirled and shot Davis with his .38. A furious exchange of shots put two more slugs into each adversary and wounded Ward and two bystanders. Both Brann and Davis died. (Courtesy Texas Collection, Carroll Library, Baylor University.)

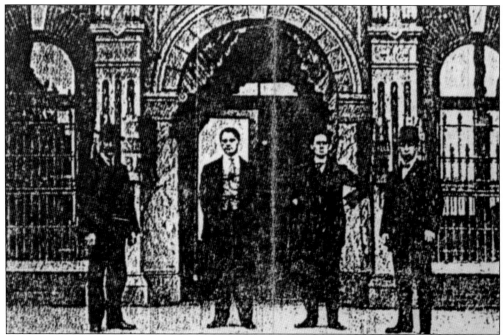

Longview was founded in the early 1870s, when the Southern Pacific Railroad built westward into East Texas. When Gregg County was organized in 1873, Longview was designated the county seat. But the town was rough, and through the years, there were several gunfights between angry citizens. In 1894, Longview's First National Bank (pictured) was assaulted by a gang led by an infamous outlaw. (Courtesy Gregg County Historical Museum.)

The notorious Dalton Gang was decimated in 1892 at an abortive bank robbery in Coffeyville, Kansas. But another brother, Bill Dalton (pictured), was second-in-command of Bill Doolin's large gang of "Oklahombres." On the run in 1894, Dalton holed up on the Houston Wallace farm, 25 miles west of Ardmore. Jim Wallace, Houston's brother, had lived in Longview and told Dalton about the prosperous First National Bank. (Courtesy Gregg County Historical Museum.)

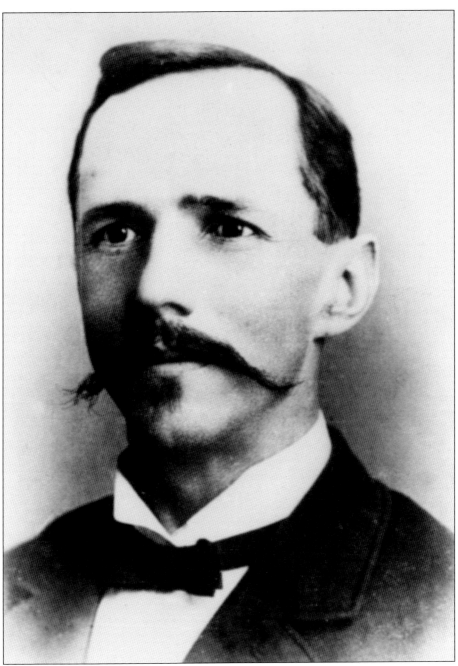

Riding together to Longview, Bill Dalton and Jim Wallace enlisted the Nite brothers, Jim and Big Asa. On May 23, 1894, Dalton and Jim Nite entered the bank, while Wallace and Big Asa waited in the back alley with the horses. Inside the bank, cashier Tom Clemmons (pictured) courageously clutched Dalton's revolver. Dalton pulled the trigger, but the hammer dropped onto the fleshy part of Clemmons's hand, between his thumb and his forefinger. Twice more, Dalton tried to fire, but each time, the only damage was a hole in the flesh of the cashier's hand. As Dalton and Clemmons grappled, Nite stuffed $2,000 into a burlap bag, while two men slipped outside to sound the alarm. (Courtesy Gregg County Historical Museum.)

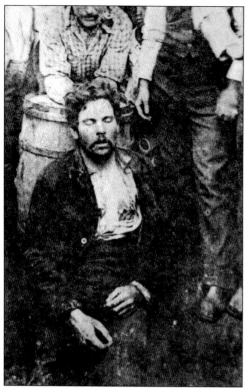

As armed citizens hurried to the scene, Jim Wallace (above) began shouting war whoops and firing his brace of revolvers. He gunned down bartender George Buckingham, city marshal Matt Muckleroy, Charles Learn, and J.W. McQueen, and, with a single round, he nicked two bystanders. Buckingham and McQueen were fatally wounded. But from a window behind Wallace, J.C. Lacy squeezed off a Winchester round that instantly killed the crazed gunman. The surviving outlaws used Tom Clemmons and his brother Joe as hostages to escape town, then galloped away from a pursuit posse. Meanwhile, furious citizens hanged Wallace's corpse (right) from a nearby telegraph pole. (Both, courtesy Gregg County Historical Museum.)

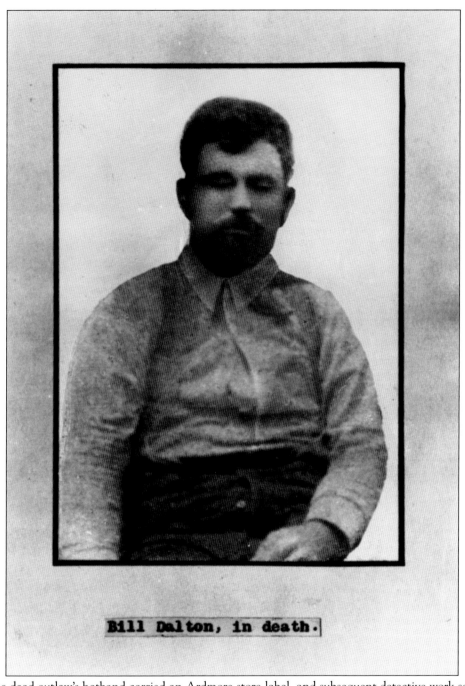

Bill Dalton, in death.

The dead outlaw's hatband carried an Ardmore store label, and subsequent detective work sent a nine-man posse to Houston Wallace's farm. Dalton tried to flee, but he was shot dead. Dalton's embalmed body was identified by Tom Clemmons and the Gregg County sheriff, then was placed on display for five days. The Nite brothers surfaced three years later in West Texas. Big Asa was killed by a posse, which captured Jim. Tried in Longview, he was sentenced to 20 years in prison. Jim Nite was paroled in 1911, but in 1920, he was killed during an attempted robbery in Tulsa. (Courtesy Gregg County Historical Museum.)

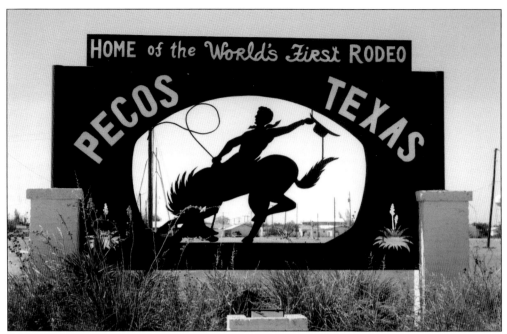

Pecos was a cowboy town that claimed the world's first rodeo, a series of cowboy contests staged at the Fourth of July in 1883. In 1887, gunfighter Clay Allison died outside town, and he is buried beside a Pecos museum. During the 1890s, Killin' Jim Miller served a term as city marshal. Sheriff Bud Frazer feuded with Miller, and in 1894, those men twice traded shots on the streets of Pecos. In 1896, Miller killed Frazer in another town, and he also began a feud with Barney Riggs, an ex-convict who had earned a pardon by killing another inmate during a prison break. John Denson and Bill Earhart, two of Miller's henchmen from Fort Stockton, came after Riggs in a Pecos saloon. But Riggs killed both men. Today, the saloon is a museum complete with bullet holes. (Both photographs by the author.)

Seven

END OF THE TRAIL

Across the Old West, gunfighting was a lethal exercise largely of the 1800s. But in Texas, with its long tradition of frontier violence, gunfighters continued their deadly activities into the 20th century. Pink Higgins, who had used his guns against Comanche warriors, stock thieves, and personal adversaries since he was a teenager, clashed with fellow range detective Bill Standifer in 1902. Although in his 50s, Pink rode out to meet Standifer in a mano a mano rifle duel. Killin' Jim Miller, headquartering in Fort Worth, continued to shoot one victim after another until he was lynched in 1909.

In the second decade of the 20th century, the last old-fashioned Texas blood feud broke out between two ranching families. West Texans continued to embrace the values and attitudes of the frontier, even in a new century. They still bristled with the violent impulses of the pioneers who had settled the region only a generation earlier. And the most tragic victim of this feud was the oldest son of frontier feudist Pink Higgins.

Nostalgic remnants of the gunfighter era in Texas include Tascosa's Boot Hill, Fort Worth's Oakwood Cemetery, and El Paso's Concordia Cemetery. The Orient Saloon in Pecos offers the site of a fatal gunfight, complete with bullet holes. There are superb gun collections at Waco's Texas Ranger Hall of Fame and Museum and at San Antonio's Buckhorn Museum, as well as more modest collections at smaller museums around the state.

The gunfighter culture was exaggerated and transmitted by fiction and motion pictures. The fast-draw myth was invented by Hollywood, which filmed as many as 300 Western movies per year. In the 1950s and 1960s, television brought Western gunfighting into homes through weekly television series. The gunfighters of the 1800s all are gone, but Texans remain keenly aware of their state's gunfighting traditions.

Pink Higgins left Lampasas County for a job as stock detective with the vast Spur Ranch, which was being raided by rustlers. Pink's towering reputation as a gunslinger intimidated several known rustlers, who moved to New Mexico. "Cattle leakage" on the Spur Ranch sharply declined. Pink built a board-and-batten house for his family on his small spread, the "Catfish Ranch." (Author's collection.)

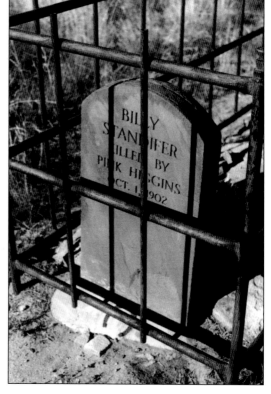

At the Spur Ranch, Pink Higgins clashed with his fellow stock detective, Bill Standifer. A native of Lampasas County and a one-time sheriff, Standifer nursed an old grudge toward Higgins. A challenge was issued, and on October 1, 1902, the two men met for a rifle duel near Pink's home. Pink's horse was mortally wounded, but Higgins drilled Standifer in the chest. Standifer was buried where he fell. (Photograph by the author.)

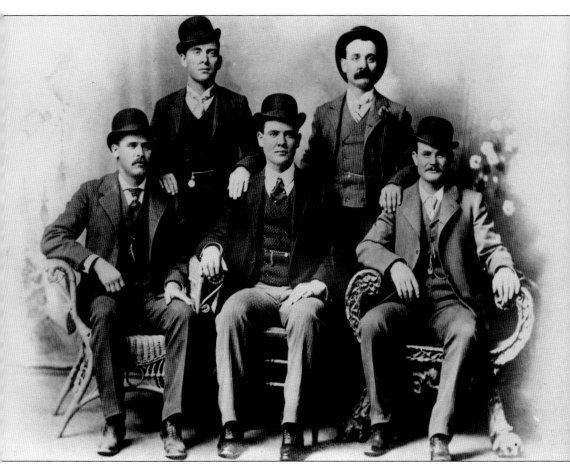

Hell's Half Acre, Fort Worth's notorious red-light district, continued to flourish into the new century. By December 1900, following a bold bank robbery in Winnemuca, Nevada, Butch Cassidy and several members of his "Wild Bunch" were in Fort Worth to vacation at Hell's Half Acre. While there, five gang members, dressed in party clothes, went to the photography studio of John Swartz, at 705 Main Street. The group photograph of the "Fort Worth Five" includes, from left to right, (seated) Harry Longabaugh (Sundance Kid), Ben Kilpatrick, and Butch Cassidy; (standing) Will Carver and Harvey Logan. The outlaws soon moved on to San Antonio's red-light district, while Swartz placed the handsome photograph in his studio window. Someone recognized the fugitives and sent the photograph to the Pinkerton Detective Agency. (Courtesy Western History Collections, University of Oklahoma Library.)

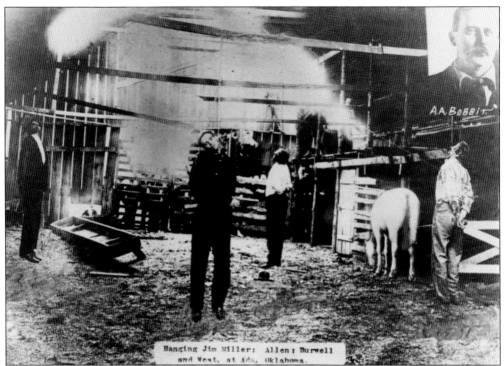

Hanging Jim Miller: Allen, Burwell and West, at Ada, Oklahoma.

Killin' Jim Miller's wife, Sallie, operated a Fort Worth boardinghouse, where he stayed between jobs. In 1909, he was employed by three Oklahoma cattlemen who had been feuding with Gus Bobbitt, whose spread was near Ada. On February 26, Bobbitt was driving a supply wagon toward his home when Miller blasted him with both barrels of his shotgun. Mrs. Bobbitt dashed out to hold her dying husband, while Miller fled to Fort Worth. Texas officials were happy to extradite Miller to Oklahoma, and Killin' Jim was thrown in jail with his three employers. On April 19, a lynch mob carried the prisoners to an Ada livery stable. After the nooses were fitted, Miller (above, far left) coolly asked for his hat to be placed on his head. Dead at 42, he was taken back to Fort Worth for burial. (Above, courtesy Western History Collections, University of Oklahoma Library; below, photograph by the author.)

The graves of three noted gunfighters, Luke Short, Jim Courtright, and Jim Miller, may be found at Fort Worth's Oakwood Cemetery. Oakwood, known as the "Westminster Abbey of Fort Worth," provides a walking history of lethal gunfighters, powerful cattle barons, local heroes, Confederate veterans, business tycoons, writers, and musicians. (Photograph by the author.)

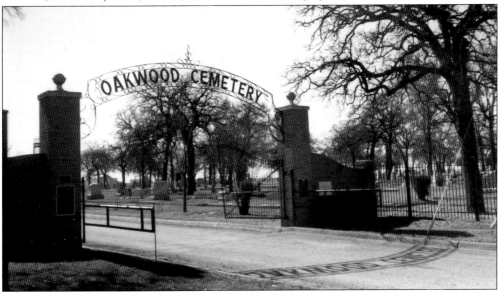

When Oakwood Cemetery was established north of downtown Fort Worth, there were no bridges across the Trinity River. A funeral procession followed a horse-drawn hearse to a ford, which led to the cemetery. But when the river ran high, less devoted mourners would turn back at the ford. A saying resulted: "He is a good friend; he will follow you all the way across the river." (Photograph by the author.)

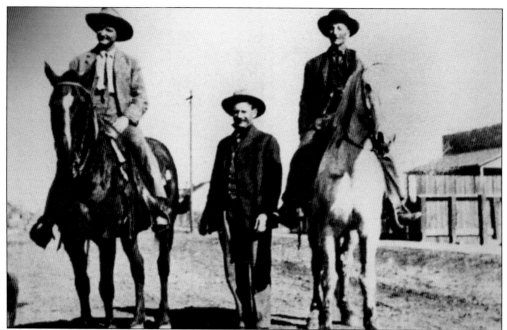

The Arizona Rangers were organized in 1901 to halt the rampant outlawry that was the main reason the US Congress would not grant statehood to Arizona Territory. The Arizona Rangers were modeled on the Texas Rangers, and several Texas Rangers migrated to Arizona Territory to pin on a badge. Sgt. Billy Old of the Texas Rangers became Lieutenant Old of the Arizona Rangers. Mounted at left, Old rode as an Arizona Ranger from 1904 to 1908. (Courtesy Arizona Historical Society.)

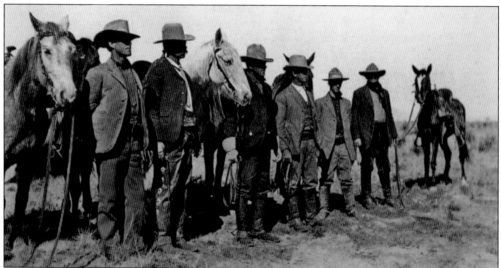

The maximum strength of the Arizona Ranger company was 26 men. During the life of the company (1901–1909), a total of 107 men served as Rangers, and 44 of them (41 percent) were from Texas. Texans with the instincts of a frontier manhunter could find plenty of wrongs to right in Arizona Territory. Capt. Harry Wheeler, standing at left, led this 1907 patrol. Next to him is Sgt. Rye Miles from Texas, and standing fourth from left is Texan Oscar McAda. (Courtesy Arizona Historical Society.)

By 1908, the Arizona Rangers had killed or imprisoned or hounded out of the territory the worst of Arizona's criminals. The most troublesome badman remaining in Arizona Territory was Texan William F. Downing (right), and he was confronted by Texan Billy Speed (below), an Arizona Ranger since 1906. Downing, a convict, operated the Free and Easy Saloon in Willcox, where Ranger Speed was stationed. The Free and Easy became a nefarious dive, and Downing, who packed a revolver in his hip pocket, threatened Speed on multiple occasions. Capt. Harry Wheeler warned Speed to be ready to kill Downing. On August 5, 1908, following a drunken rampage, Downing met Speed in the street, groped for his hip pocket, and was mortally wounded by a Winchester bullet. (Both, courtesy Arizona Historical Society.)

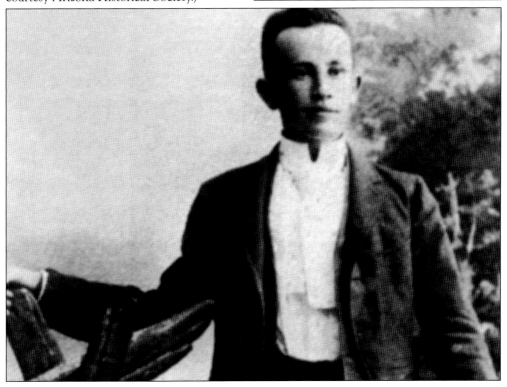

In 1907, there was a street shootout in Winnsboro, with all of the elements of 19th-century gunplay. City marshal Amos Wofford and his brother, Constable John Wofford, clashed with saloon owner Dick Milam and his son, Bud. The conflict came to a head on February 3 in the Bowery, Winnsboro's two-block district of saloons and dives. The explosion of gunfire rattled nearby store windows. All four adversaries were hit. The Wofford brothers died where they fell, and so did Dick Milam. Bud Milam survived the fight but died of his wounds nine days later. It was a classic Wild West gunfight: peace officers versus saloon men, with four shootists fatally wounded. The author stands at the site. (Photograph by Karon O'Neal.)

Billy Johnson was a teenaged drover on an 1878 cattle drive when he discovered a spring-fed creek on the open grasslands of northern Scurry County. Johnson built a large ranch on this prime frontier property. He married and raised three sons and a daughter on the ranch, teaching all four children to ride and shoot. (Courtesy Betty M. Giddens.)

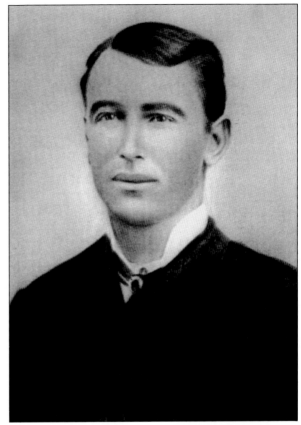

Successful as a rancher, Billy Johnson also founded the First National Bank of Snyder and, in 1910, built a 16-room mansion on his ranch. He spoiled his daughter, Gladys, who became headstrong and hot-tempered. (Photograph by the author.)

In 1887, Dave and Laura Belle Sims brought their cattle herd and growing family to rugged, isolated Kent County. Dave acquired more than 25,000 acres and built this frame house, which still stands. Eventually, there were 10 Sims children. The oldest son, Ed Sims, fell in love with pretty Gladys Johnson, who lived on her father's ranch just 15 miles to the south. (Photograph by the author.)

In 1905, Ed Sims, 21, married 14-year-old Gladys Johnson. Billy Johnson helped the couple acquire a ranch south of Post City, seat of Garza County. Ed and Gladys had two daughters, but instead of the happy union of two ranching families, the marriage became turbulent and adulterous. In 1916, there was a contentious divorce. (Courtesy Charles Anderson Sr.)

118

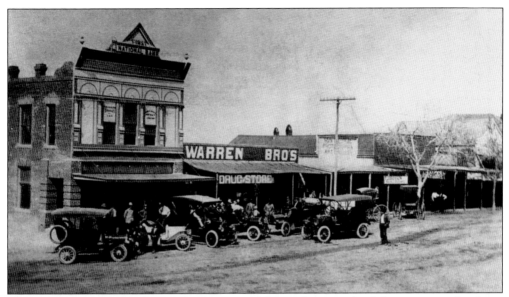

Gladys moved back to her father's luxurious ranch house, but custody of the two young daughters became a bitter problem between the divorced couple. Hard feelings exploded into murderous violence on Saturday, December 16, 1916, when Gladys was supposed to deliver her daughters to Ed in front of the First National Bank (the two-story building). But Gladys shot Ed when he approached her car, and her brother Sid came from the bank and finished him with a shotgun. (Courtesy Scurry County Museum, Snyder.)

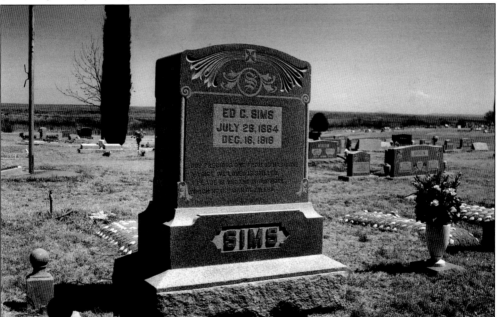

Ed Sims was buried in the Post City Cemetery, and the sentiment on his gravestone was heartfelt: "Our precious one from us is gone. A voice we loved is stilled, a place is vacant in our home, which never can be filled." It was the second decade of the 20th century, but both families were shaped by the frontier values of the 1800s, and an old-fashioned blood feud ensued. (Photograph by the author.)

Following the shooting, gunmen were hired and the violence escalated. Billy Johnson employed as bodyguards Harrison Hamer and his brother Frank (pictured). Frank Hamer and Gladys Johnson Sims fell in love and were married. Frank and Gladys had two sons and a happy marriage, and in 1934, the experienced lawman earned lasting fame by hunting down Bonnie and Clyde. (Author's collection.)

On October 1, 1917, Frank and Gladys Hamer, traveling with brothers Harrison Hamer and Emmett Johnson, were ambushed by gunmen led by Gee McMeans, a Sims son-in-law. The shootout took place in Sweetwater, at the left edge of this photograph. McMeans shot Hamer in the left arm and leg, but Frank, a southpaw, drilled his assailant in the heart with his right hand. Meanwhile, Gladys thwarted the advance of a second gunman with her automatic. (Courtesy Pioneer Museum, Sweetwater.)

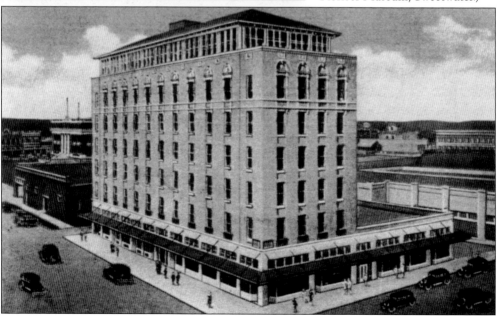

Cullen Higgins, oldest son of Pink, was a former district judge and an excellent attorney whose office was on the second floor of Billy Johnson's bank. Cullen skillfully secured the exoneration of both Gladys and her brother in the murder of Ed Sims. A three-man hit team succeeded in assassinating Judge Higgins by shotgun. His death at 42 brought an enormous funeral crowd to Snyder. (Courtesy Samantha Usnick.)

The three-story Nolan County jail stood on the northeast corner of the Sweetwater square. Si Bostick, arrested soon after the assassination of Cullen Higgins, was brought to the jail's vacant third floor in the middle of the night. Coerced into revealing the location of the murder weapon and the identity of his confederates, Bostick was found dead in his cell the next morning. A highly improbable suicide was ruled. (Courtesy Pioneer Museum, Sweetwater.)

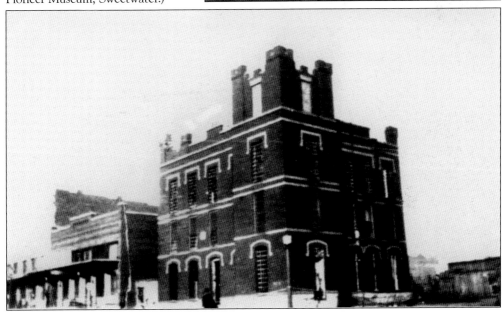

For those interested in the gunfighter lore of Texas, there is no more rewarding place to visit than the Texas Ranger Hall of Fame and Museum in Waco. There are superb displays of famous Texas Rangers and notable Ranger events. (Photograph by the author.)

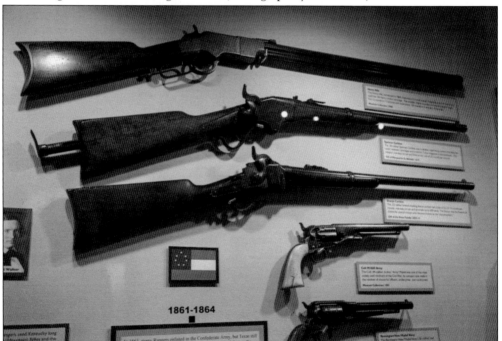

1861-1864

The gun collection in the Texas Ranger Hall of Fame and Museum is magnificent. Rangers were instrumental in the evolution of the revolving pistol, an evolution made obvious by gun after gun. There is a vast array of shoulder guns as well, along with bowie knives. Every manner of 19th-century firearm is on display, as well as many historic guns of the 20th century. (Photograph by Dr. Berri O'Neal.)

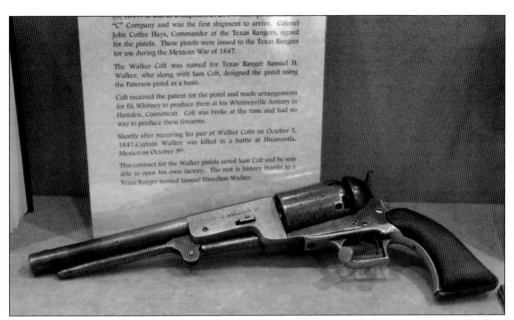

The text visible in the photograph reads:

"C" Company and was the first shipment to arrive. Colonel John Coffee Hays, Commander of the Texas Rangers, signed for the pistols. These pistols were issued to the Texas Rangers for use during the Mexican War of 1847.

The Walker Colt was named for Texas Ranger Samuel H. Walker, who along with Sam Colt, designed the pistol using the Paterson pistol as a basis.

Colt received the patent for the pistol and made arrangements for Eli Whitney to produce them at his Whitneyville Armory in Hamden, Conneticut. Colt was broke at the time and had no way to produce these firearms.

Shortly after receiving his pair of Walker Colts on October 5, 1847, Captain Walker was killed in a battle at Huamantla, Mexico on October 9th.

This contract for the Walker pistols saved Sam Colt and he was able to open his own factory. The rest is history thanks to a Texas Ranger named Samuel Hamilton Walker.

Another Texas Ranger museum, housed in San Antonio's Buckhorn Saloon, features hundreds of artifacts. The Buckhorn opened in 1881. No longer at its historic location, the Buckhorn Saloon today is two blocks from the Alamo and is a popular tourist destination. Among the variety of displays is an excellent collection of frontier weaponry. (Photograph by the author.)

In Pecos, the Orient Saloon still stands beside the Orient Hotel in front of the railroad tracks. In the saloon, bartender Barney Riggs killed John Denson and Bill Earhart, and bullet holes are prominently marked. The adjoining hotel utilizes 50 rooms for historic displays. Behind these buildings is the grave of Clay Allison, along with a replica of Judge Roy Bean's Jersey Lily Saloon. (Photograph by the author.)

Tascosa's Boot Hill is the final resting place of numerous 1880s gunfight victims, including the three LS cowboys and the luckless bystander who died in "the Big Fight" of 1886. (Photograph by the author.)

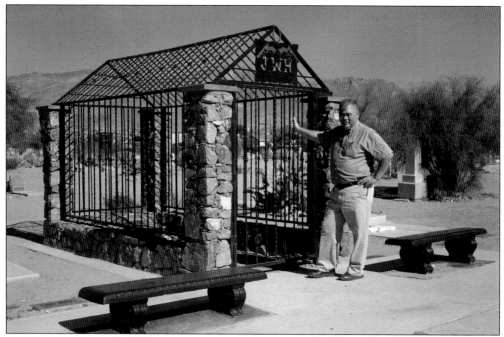

Concordia Cemetery in El Paso stands beside busy Interstate 10, with the Franklin Mountains as an impressive backdrop. John Wesley Hardin is Concordia's most famous inhabitant. John Selman, who killed Hardin, also is at Concordia, along with buffalo soldiers, Civil War veterans, and Chinese railroad laborers. Hardin's grave is shown here. (Photograph by the author.)

Gunfighting became a major element in Western fiction and motion pictures. The pulp magazine pictured here was published in April 1938 and featured short stories about fast-shooting Texas Rangers. (Author's collection.)

The enormously successful western novelist Zane Grey often centered his books on Texas Rangers. Grey's novels were filmed, frequently in multiple versions. In 1924, Tom Mix, the most popular Western star of the silent screen, starred in Grey's *The Lone Star Ranger*. In his publicity, Mix claimed to have served as a Texas Ranger. (Author's collection.)

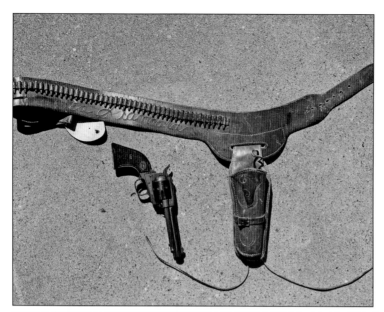

The buscadero rig was popularized by Hollywood Westerns, as fast-draw scenes added drama to the silver screen. Movie and television fast-draw rigs featured a dropped panel with a slot on the gun belt for a low-slung holster that was tied down above the knee. Sometimes, the holsters were tilted for even faster draws. Such gun-belt and holster combinations were unknown on the frontier. (Photograph by the author.)

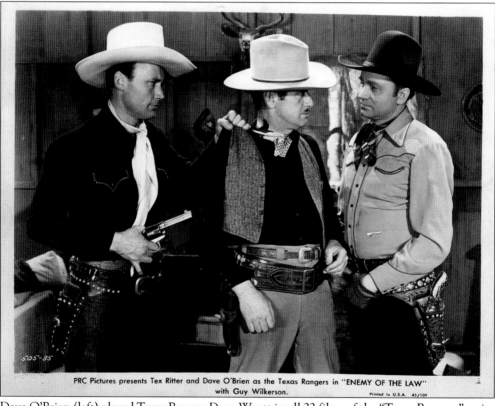

PRC Pictures presents Tex Ritter and Dave O'Brien as the Texas Rangers in "ENEMY OF THE LAW" with Guy Wilkerson.

Printed in U.S.A. 45/109

Dave O'Brien (left) played Texas Ranger Dave Wyatt in all 22 films of the "Texas Rangers" series (1942–1945). Tex Ritter (right) costarred in the last eight films, including *Enemy of the Law*. All three actors wear buscadero rigs, and Ritter's is handsomely tooled. Ritter starred in 60 Western films; in countless gunfighting scenes, he beat his opponent to the draw, often shooting the gun out of his hand. (Author's collection.)

Sunset Carson grew up in the Panhandle of Texas and became a rodeo star. Tall and good-looking, he starred in B-Westerns during the 1940s. With his fancy buscadero rig, he was a fast-draw artist in his films. (Author's collection.)

In *The Comancheros*, a major motion picture of 1961, John Wayne played a Texas Ranger, Capt. Jake Cutter. Skilled with firearms throughout the film, he outdrew and killed Lee Marvin during a saloon fight. (Author's collection.)

DISCOVER THOUSANDS OF LOCAL HISTORY BOOKS FEATURING MILLIONS OF VINTAGE IMAGES

Arcadia Publishing, the leading local history publisher in the United States, is committed to making history accessible and meaningful through publishing books that celebrate and preserve the heritage of America's people and places.

Find more books like this at
www.arcadiapublishing.com

Search for your hometown history, your old stomping grounds, and even your favorite sports team.